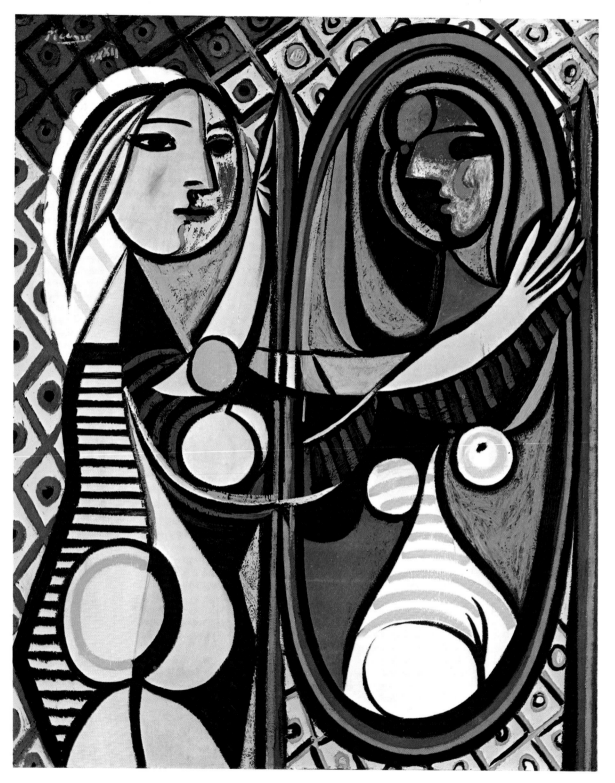

PICASSO: *Girl Before a Mirror.* 1932. Oil, 64¾ x 51¼". Museum of Modern Art, gift of Mrs. Simon Guggenheim.

WHAT IS MODERN PAINTING?

REVISED
EDITION

ALFRED H. BARR, JR.

THE MUSEUM OF
MODERN ART
NEW YORK

DISTRIBUTED BY
NEW YORK
GRAPHIC SOCIETY
BOSTON

TRUSTEES OF THE MUSEUM OF MODERN ART

As of December 1987

Copyright © 1943 by The Museum of Modern Art, renewed 1970; 1947, renewed 1974; 1952; 1956
All rights reserved
Library of Congress Catalog Card Number 75-13926
ISBN 0-87070-631-4

Ninth edition, sixth printing 1988

THE MUSEUM OF MODERN ART
11 WEST 53 STREET
NEW YORK, NY 10019
PRINTED IN THE UNITED STATES OF AMERICA

CONTENTS PAGE

This booklet is written for people who have had little experience in looking at paintings, particularly those modern paintings which are sometimes considered puzzling, offensive, incompetent or crazy. It is intended to undermine prejudice, disturb indifference and awaken interest so that some greater understanding and love of the more adventurous painting of our day may follow.

This is not a history, and the pictures are not arranged chronologically; nor does this present a panorama or balanced survey of contemporary painting: portraiture and mural painting, for instance, are comparatively neglected, and no attention has been paid to national schools, though artists of the United States are far more numerously represented than those of any other country.

Some of the paintings reproduced are world famous masterpieces; others by comparison are minor works; but all are by artists of established reputation. Most of the paintings have been chosen from the Collection of The Museum of Modern Art.

Since color is such an important element in modern painting a special effort has been made to include pictures of which the Museum has already published color reproductions.

The most grateful thanks are offered to Victor D'Amico of the Museum Staff, and others, particularly teachers and students in colleges and secondary schools, who read the text before publication. Their friendly and sometimes patiently detailed suggestions have been of great practical, and educational, value to the writer. Criticisms by reviewers of previous editions, notably those of H. W. Janson in the *College Art Journal,* have been studied with care in preparing this edition.

A. H. B., Jr.
New York, 1959

WHAT IS MODERN PAINTING? It is not easy to answer this question in writing, for writing is done with words while paintings are made of shapes and colors. The best words can do is to give you some information, point out a few things you might overlook, and if, to begin with, you feel that you don't like modern painting anyway, words may help you to change your mind. But in the end you must look at these works of art with your own eyes and heart and head. This may not be easy, but most people who make the effort find their lives richer, more interesting, more worth living.

WHAT IS MODERN PAINTING? Stop reading a few minutes, turn the pages of this booklet and look at the pictures, keeping in mind that these small reproductions represent paintings which actually are very different in size and color.

What is your first impression? Bewildering variety? Yes, that is true. The variety of modern art reflects the complexity of modern life. Though this may give us mental and emotional indigestion, it does offer each of us a wide range to choose from.

But it is important not to choose too quickly. The art which makes a quick appeal or is easy to understand right away may wear thin like a catchy tune which you hear twice, whistle ten times and then can't stand any more.

It is just as important not to fool yourself. Don't pretend to like what you dislike or can't understand. Be honest with yourself. We don't all have to like the same things. Some people have no ear for music; a few have no eye for painting — or say they haven't because they are timid or don't want to make the effort.

Yet everybody who can see has an eye for pictures. Most of us see hundreds, maybe thousands, of pictures every week, a few of them very good ones too — photographs in newspapers and magazines, cartoons, illustrations and comics, advertising in buses and subways: Joe Palooka Happy Atom Scientists Buy Sweetie Pie Soap Buck Rogers Vote For McLevy Dallam Scores In Plane Crash Near Trenton Zowie The Pause That Refreshes — pictures which try to get you to buy this or that, tell you something you may forget tomorrow or give you a moment's lazy entertainment. (And do you remember the pictures on the walls of your home?)

When you look at the pictures in this booklet you may be upset because you can't understand them all at first glance. These paintings are not intended to sell you anything or tell you yesterday's news, though they may help you to understand our modern world.

Some of them may take a good deal of study, for although we have seen a million pictures in our lives we may never have learned to look at painting as an art. For the art of painting, though it has little to do with words, is like a language which you have to learn to read. Some pictures are easy, like a primer, and some are hard with long words and complex ideas; and some are prose, others are poetry, and others still are like algebra or geometry. But one thing is easy, there are no foreign languages in painting as there are in speech; there are only local dialects which can be understood internationally for painting is a kind of visual Esperanto. Therefore it has a special value in this riven world.

The greatest modern artists are pioneers just as are modern scientists, inventors and explorers. This makes modern art both more difficult and often more exciting than the art we are already used to. Galileo, Columbus, the Wright brothers suffered neglect, disbelief, even ridicule. Read the lives of the modern artists of eighty years ago, Whistler or van Gogh for instance, and you will keep an open mind about the art you may not like or understand today. Unless you can look at art with some spirit of adventure, the pioneer artists of our own day may suffer too. This might be your loss as well as theirs.

Perhaps you feel that these pictures have little to do with our everyday lives. This is partly true; some of them don't, and that is largely their value — by their poetry they have the power to lift us out of humdrum ruts. But others have a lot to do with ordinary life: vanity and devotion, joy and sadness, the beauty of landscape, animals and people, or even the appearance of our houses and our kitchen floors. And still others have to do with the crucial problems of our civilization: war, the character of democracy and tyranny, the effects of industrialization, the exploration of the subconscious mind, the survival of religion, the liberty and restraint of the individual.

The artist is a human being like the rest of us. He cannot solve these problems except as one of us; but through his art he can help us see and understand them, for artists are the sensitive antennae of society.

Beyond these comparatively practical matters art has another more important function: the work of art is a symbol, a visible symbol of the human spirit in its search for truth, for freedom, for perfection.

It is good to rest the eye on Dean Fausett's peaceful Vermont valley. The style of *Derby View*, the way it is painted, is as relaxed and free from strain as the subject. The artist has spread before you the panorama of green hills with broad, easy brush strokes. The paint itself has a fresh beauty of color and texture which unobtrusively enhances the pictured beauty of the landscape.

Fausett, though he is a young American, paints his summer scene in a manner handed down from English artists of over a hundred years ago. Stuart Davis is older than Fausett but he works in a more "modern" style. Davis' *Summer Landscape* does not depend for its chief interest upon what the artist saw in nature but upon how he has changed what he saw.

The photograph opposite, although it was taken in winter with no leaves on the trees, shows the scene on which Davis based his picture. Comparing it with the painting we can see how the artist has transformed a prosaic, commonplace view into a lively, decorative composition.

How did he go about it? First he drew the forms in simple outlines, leaving out unimportant or confusing details and reducing board fences, clouds and ripples to a lively linear shorthand. By omitting all shadows he lets you see these essential shapes and patterns more clearly. He moves houses around and even keeps half the house to the left of the telephone pole while throwing the other half away — probably without your noticing it. But with all these omissions and simplifications and rearrangements Davis has given a clearer and more complete idea of the village than does the snapshot. And when you see the original painting you may agree that he has not only created a crisp, vivacious, gayly colored design but has even caught the lighthearted spirit of a summer day.

Perhaps when you compare Fausett's *Derby View* and Davis' *Summer Landscape* you will find it hard to choose between them, but it is not hard to decide which shows the more imagination, the greater will to select, control, arrange and organize.

FAUSETT: *Derby View*. 1939. Oil, 24⅛ x 40". Museum of Modern Art. *Dean Fausett*, American, born 1913.

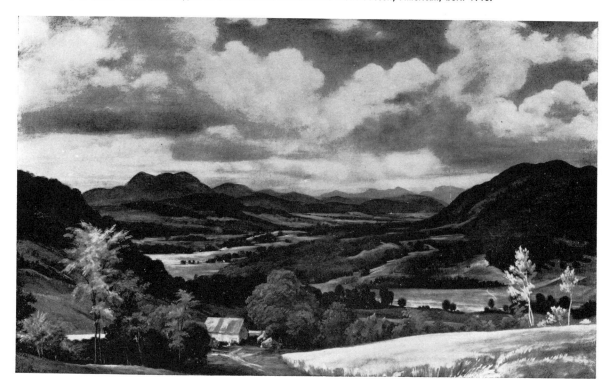

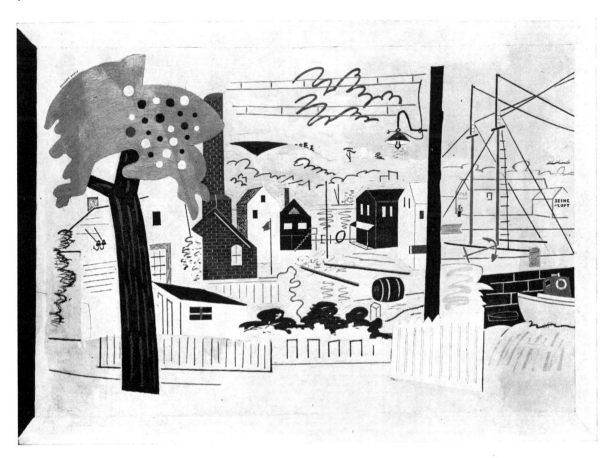

DAVIS: *Summer Landscape.* 1930. Oil, 29 x 42". Museum of Modern Art. *Stuart Davis, American, 1894-1964.*

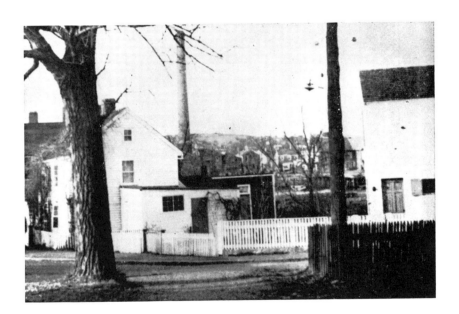

Photograph of the original scene upon which Davis based his painting *Summer Landscape.*

To help us not to forget World War II, its glory and its agony, we have these two paintings, one of them by a young English artist, the other by a famous Mexican. Both were painted in 1940 but they are so unlike that they seem done in different centuries, even in different worlds.

In the foreground of Richard Eurich's *Withdrawal from Dunkirk* British troops, thick as ants, are ferried out through the surf to embark on small steamers and fishing craft. At the right a destroyer swings away toward England; and in the distance beyond the lighthouse rises a vast, black umbrella of smoke. The painter has recorded all this patiently, with exact detail and British reticence. His picture is as calm as the blue sky above the scene, clearer than a photograph and almost as impersonal. From the way he paints you would not guess that his subject was one of the crucial and overwhelmingly dramatic moments of the entire War.

Orozco's mural *Dive Bomber and Tank* (below) was painted two months after Dunkirk. His mind, like ours, was full of the shock of the mechanical warfare which had just crushed western Europe. But instead of picturing an actual incident with technically accurate details he makes us feel the essential horror of modern war — the human being mangled in the crunch and grind of grappling monsters "that tear each other in their slime." We can see suggestions of the bomber's tail and wings, of tank treads and armor plate and human legs dangling from the jaws of shattered wreckage. Beneath emerge three great sightless masks weighted with chains which hang from pierced lips or eyes. These ancient symbols of dramatic agony and doom are fused with the shapes of modern destruction to give the scene a sense of timeless human tragedy.

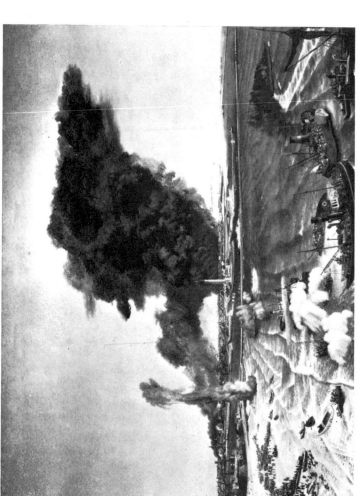

EURICH: *Withdrawal from Dunkirk.* 1940. Oil, 30 x 40". Owned by the British Government. *Richard Eurich* (Yurik), British, born 1903.

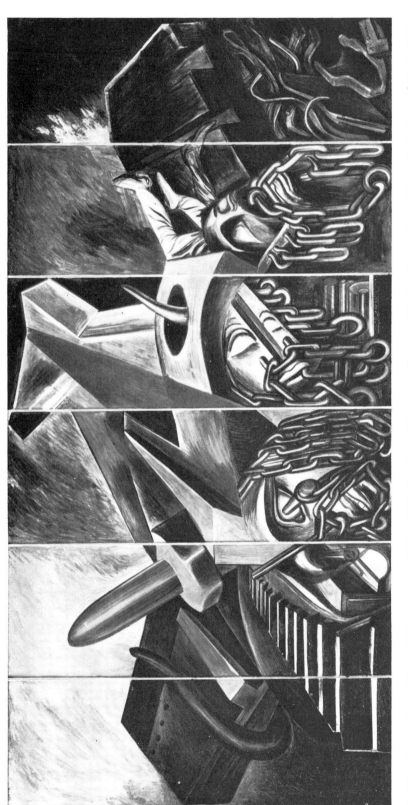

OROZCO: *Dive Bomber and Tank.* 1940. Fresco, 9 x 18 feet, divided into 6 movable panels. Museum of Modern Art, commissioned through the Abby Aldrich Rockefeller Fund. José Clemente Orozco, Mexican, 1883-1949.

As you can see, Orozco makes full use of the modern artist's freedom: he combines real and unreal objects, employs the cubist technique of breaking up nature into half-abstract, angular planes (page 28), and uses emphatic, emotional, expressionist drawing (page 21).

Eurich's technique was developed five hundred years ago. Orozco's belongs to the twentieth century. Stop a moment and look at them both again. Subject matter aside, which style, which way of painting means more to you? Or do both have value?

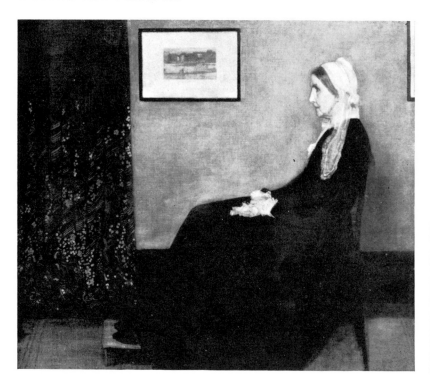

WHISTLER: *Arrangement in Grey and Black (Portrait of the Artist's Mother).* c. 1871. Oil, 56 x 64". The Louvre Museum, Paris. James Abbot McNeill Whistler, American, b. Lowell, Mass., 1834. Studied in Paris and lived mostly in England. Died in London, 1903.

Diagram showing the main lines of Whistler's composition with the figure omitted. Compare the Mondrian, p. 29.

In 1877 John Ruskin, the renowned art critic, visited an exhibition where he saw several paintings by Whistler, who had for years been the storm center of art in London. Ruskin was outraged, called Whistler impudent and accused him of "flinging a pot of paint in the public's face." Whistler brought suit for libel but the trial was a farce; the public and the court sided with Ruskin, and Whistler, although he won half a cent damages, was forced into bankruptcy by legal expenses.

It was really the freedom of the artist which had been on trial. Ruskin and the public insisted that painting should be an exact, detailed, realistic picture of some object, scene or event. Whistler answered — but let him use his own words:

"The vast majority of folk cannot and will not consider a picture as a picture, apart from any story which it may be supposed to tell . . . As music is the poetry of sound, so is painting the poetry of sight, and the subject matter has nothing to do with harmony of sound or of color.

"Take the picture of my mother, exhibited at the Royal Academy as an *Arrangement in Grey and Black*. Now that is what it is. To me it is interesting

as a picture of my mother; but what can or ought the public to care about the identity of the portrait?"

Whistler's *Mother* did not actually figure in the trial. It was painted six years before and, though this is hard to believe now, it had been rejected when Whistler sent it to the annual national exhibition at the Royal Academy. Only after one of the more open-minded members threatened to resign was it finally exhibited. For the next twenty years it remained unsold, even traveling to America, where no one offered to buy it. Ultimately the French Government acquired it for eight hundred dollars. Forty years later, in 1932, when it was again brought to America for exhibition by The Museum of Modern Art, it was insured for $500,000.

Looking back on the astonishing story of Whistler, we can see that the public was blind and intolerant. To them the *Mother* seemed dull in color, unpleasantly flat and simplified in style. And they resented the artist's calling it an "arrangement." But Whistler was mistaken too in asking the public to ignore the human interest of his painting, the quality which has made it one of the world's most popular pictures.

Whistler's ideas were not only ahead of his time —

they were actually ahead of his own art. He wanted people to look at his paintings as "harmonies" or "arrangements" without paying attention to the subject matter. Therefore if he had followed his principles to a logical conclusion he might have made his intention clearer by leaving out the figure of his mother entirely from his *Arrangement in Grey and Black* — since he had already asked us to ignore her emotionally. We would then have had left a composition of rectangles, as in the diagram opposite. And this diagram is not very different from the abstract *Composition in White, Black and Red* (page 29) painted by Mondrian in 1936, many years after Whistler died. (Of course Whistler would have pointed out quite justly that by omitting his mother's silhouette his design had been spoiled — so let us put her back in again so that we can distinguish her from Dove's *Grandmother,* below.)

If you like you can also look at Arthur Dove's composition called *Grandmother* as an arrangement of rectangles and irregular forms, an arrangement made all the more interesting to the eye because the forms are not painted but are actual textures formed by cloth, wood, paper. But if you do look at it simply as an arrangement you will miss half

the point of the picture, for the artist in making his composition has taken a page from an old Bible concordance, some pressed ferns and flowers, a piece of faded needlepoint embroidery and a row of weathered shingles turned silvery grey with age; these he has combined into a *visual* poem, each element, each metaphor of which suggests some aspect of the idea of grandmother: her age, her fragility, her silvery hair, her patience, her piety.

So we find Whistler calling his portrait of his mother an *Arrangement in Grey and Black* and, fifty years later, Dove naming his arrangement of assorted textures and shapes *Grandmother.* During those fifty years many things happened in the history of art which help to explain how this paradox came about. But the important matter here and now is not history but the relation between yourself and these two pictures, no matter whether you prefer to look at them as compositions or portraits of old ladies or both. And the same is true of the two landscapes and the two battle pictures on the previous pages. Each pair has shown you two very different ways of treating a similar subject. Actually there are a hundred ways, a thousand — as many as there are pictures. Have you open eyes and a free mind?

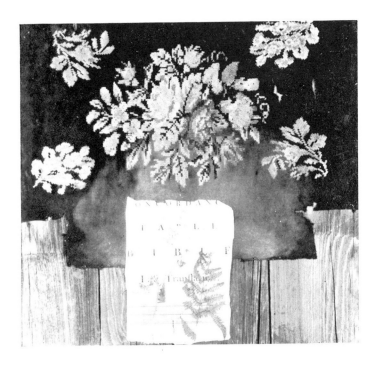

DOVE: *Grandmother.* 1925. Shingles, needlepoint, printed paper, pressed flowers, 20 x 21¼". Museum of Modern Art, gift of Philip L. Goodwin. *Arthur G. Dove, American, 1880-1946.*

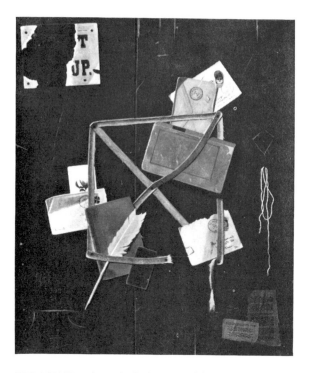

PETO: *Old Time Letter Rack* (formerly *Old Scraps.*) 1894. Oil, 30 x 25⅛". Museum of Modern Art, gift of Nelson A. Rockefeller. *John F. Peto, American, 1854-1907.*

MacIVER: *Hopscotch.* 1940. Oil, 27 x 35⅞". Museum of Modern Art. *Loren MacIver, American, born 1909.*

First let us look into some of the possibilities of realism.

If you have had little experience with paintings you probably preferred the Eurich to the Orozco, the Fausett to the Davis, the Whistler to the Dove — at first glance, anyway. For in the more realistic pictures you can recognize the subject matter or at least the *things* shown in the picture, without any more strain or trouble than if you were looking through a window, or in a mirror or at a photograph. It takes some skill to reproduce actuality as accurately as in the *Dunkirk* painting, but most artists can do it if they want to. In fact, almost anyone with good eyes and hands can learn with training and perseverance to paint a fairly good photographic effect. But a camera can do this with much less trouble and time. It is not so much the skill of hand or the illusion of reality which makes the *Dunkirk,* the *Derby View* and the pictures on these two pages works of art; it is the sensitiveness, originality and discrimination shown in selecting, arranging and painting the subject that distinguishes these realistic paintings in quality from all but the finest photographs.

In fact artists like John F. Peto were sometimes arrested for counterfeiting because their painted dollar bills were illegally exact. Such pictures as *Old Time Letter Rack* are, of course, intended to fool the eye and make you gasp at the painter's cleverness. This simple, amusing kind of realism is as old as Zeuxis, the ancient Greek artist whose painted grapes fooled even the birds. Such a trick will always have a fascination, but after the trick has stopped working you can still enjoy the arrangement of subtle color and texture if, as in the case of Peto and several of his living followers, the painter is an *artist* as well as a practical joker.

With a more serious kind of realism another American, Loren MacIver, painted *Hopscotch,* a replica of a section of road surface. She wanted not really to fool the eye but to record exactly and vividly a moment of poetic discovery when, looking down suddenly, she saw at her feet the black sun-blistered macadam conquered and adorned by the pink chalk diagram of a child's game. You can see what she saw. Can you feel what she felt?

HOMER: *The Croquet Match.*
1872. Oil, 9¾ x 15½". Collec-
tion Edwin S. Webster. *Winslow
Homer,* American, 1836-1910.

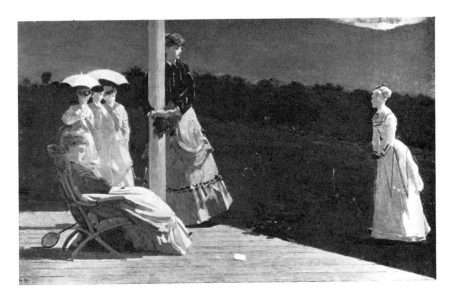

Here are two more paintings of games, one of them a sketch by the American "old master" Winslow Homer, of six girls on a summer's afternoon in the 1870s; the other by the American artist Ben Shahn, of six boys on a handball court in New York in the 1930s (when the "Affairs of Cellini" was showing at Loew's Delancey, as you can see by the billboard).

Homer said: "When I have selected the thing carefully I paint it exactly as it appears." Shahn was an expert photographer as well as a painter: he too knew how to select facts carefully.

Which painting is the more interesting to you? Do you see how they differ in composition: *Croquet* with its single white silhouette at the right balancing the cluster of girls at the left, and *Handball* with its small, agile figures dwarfed before the great blank wall? Would you suggest that the painting *Handball* is closer in spirit to *Croquet* or to *Hopscotch* (opposite)? Are the paintings on this page simply records of what the artist saw and nothing more? Does either make you think twice about the artist or the people he has painted—or about yourself?

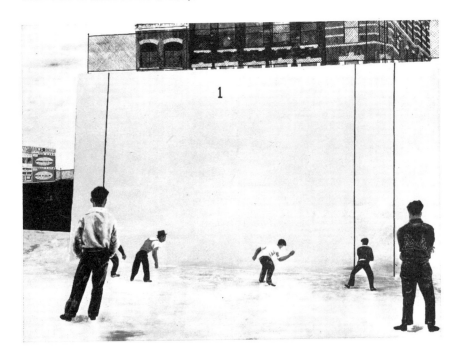

SHAHN: *Handball.* 1939. Tem-
pera on paper, 24 x 33¼".
Museum of Modern Art, Abby
Aldrich Rockefeller Fund. *Ben
Shahn,* American, born Lithuania,
1898-1969. To U.S.A. 1906.

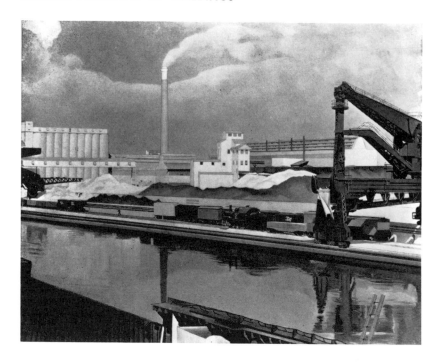

SHEELER: *American Landscape*. 1930. Oil, 24 x 31". Museum of Modern Art, gift of Abby Aldrich Rockefeller. *Charles Sheeler*, American, 1883-1965.

Realists are discoverers. Because they depend so much upon the world of actuality they often look for new and provocative things to paint, new points of view — sometimes exciting only to them at first, and then, after we have seen their paintings, exciting to us who can join in their discovery.

For instance, on this page are two kinds of build-

ings which for years people ignored or despised as architecture.

Factories used to be thought ugly and utilitarian until such artists as Charles Sheeler revealed their beauty. Sheeler, who was one of the greatest American photographers, took a series of superb photographs of the Ford plant at River Rouge before he

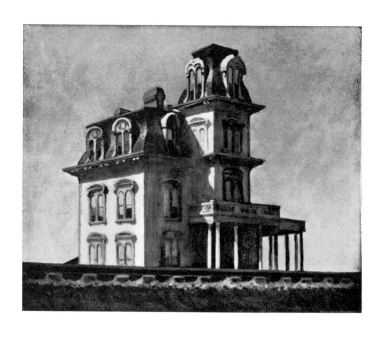

HOPPER: *House by the Railroad*. 1925. Oil, 24 x 29". Museum of Modern Art. *Edward Hopper*, American, 1882-1967.

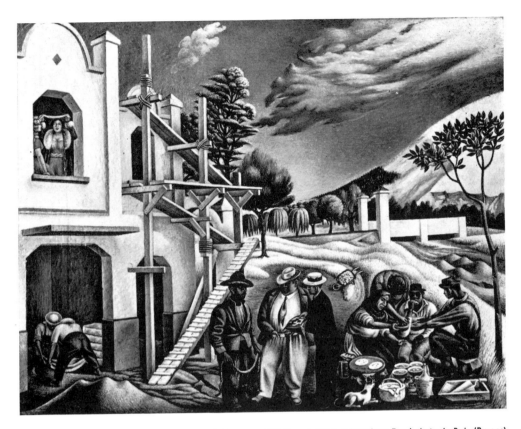

RUIZ: *The New Rich*. 1941. Oil, 12⅝" x 16⅝". Museum of Modern Art, Inter-American Fund. *Antonio Ruiz* (Ru-ees), Mexican, 1897-1964.

American Landscape. This picture is like a good photograph in its sharp-edged precision. But it goes beyond a photograph because, as Sheeler says, it is not an image recorded instantaneously and mechanically on a film, but a composite image, simplified, with certain details left out, certain adjustments made, until the effect is of a serene, almost classic perfection which photographs rarely give.

Edward Hopper also likes to paint buildings more than people, but how different is his *House by the Railroad* from Sheeler's immaculate rendering of an immaculate factory. Hopper has painted a shabby, deserted, Garfield-period mansion in bright sunlight under a cloudless sky. But, using the tracks (which have destroyed real estate values) as a kind of stage, he makes the bracketed cornices and mansard roofs rise before us with a haunting, mysterious dignity — like the face of an old woman whose blank eyes remember the past.

In the paintings of buildings by Hopper and Sheeler people are neglected; they are scarcely visible or they are dead and forgotten, and one does not miss them. But in *The New Rich* by the Mexican Antonio Ruiz, there are many people, and each of them is related in different ways to the building. Before his half-finished, bright yellow suburban house stands the man who has just got rich. He listens impatiently to the anxious contractor, who fingers his blueprints while the foreman looks on. In the window Mrs. New Rich — as well fed as her husband — is already trying curtain material. At the right three workmen eat the tortillas which one of their wives, kneeling in the road, has just cooked for them.

This is a story picture, a social satire with humor added. But the indignation of the satirist and the skill of the storyteller are given life by the arts of the painter: a gift for composition, a sense of color (acid and Mexican) and of firm, rich paint texture.

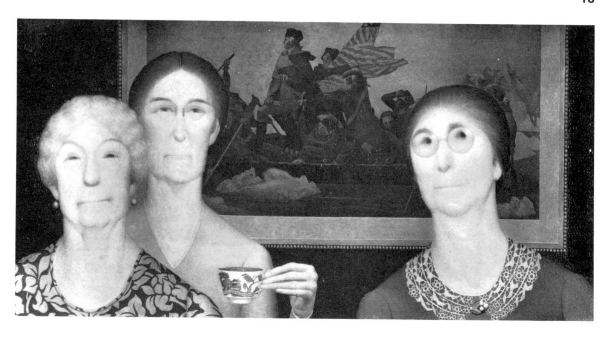

Compared with these two pictures the satirical realism of Ruiz is gentle and indirect. You can tell at a glance what Gropper and Wood want to say. Both are ruthless in their demolition of pomposity or pride. But their methods differ.

William Gropper avoids detail and slashes in his characters with bold strokes. Their attitudes and gestures betray them — the feet on the chair, the oratorical arm-flinging.

Grant Wood loved exact, close-up detail, but not for its own sake. The different kinds of eyes, the prim lace collar, the hand with the "colonial" teacup, the yellowed patriotic engraving all reinforce the disquieting effect of these virtuous, tight-lipped faces.

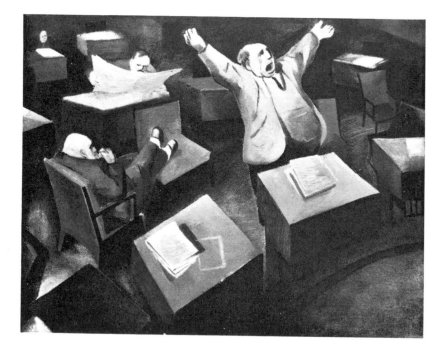

above: WOOD: *Daughters of Revolution.* 1932. Oil, 20 x 40". Cincinatti Art Museum. *Grant Wood, American, 1892-1942.*

left: GROPPER: *The Senate.* 1935. Oil, 25⅛ x 33⅛". Museum of Modern Art, gift of A. Conger Goodyear. *William Gropper, American, 1897-1977.*

It is remarkable that today several amateur, self-taught artists are more admired than many highly trained professional painters, whose polished techniques and conventional minds often make dull pictures. Among thousands of amateur painters a few combine real originality with an instinctive mastery of color and design. The greatest of these "modern primitives" was Henri Rousseau, whose *Sleeping Gypsy* is reproduced on page 35.

John Kane worked in Pittsburgh as a miner, steel worker, house painter and carpenter. He wrote: "I began painting steel cars, and in this way learned the use of paint . . . I had always loved to draw. I now became in love with paint. Carpentry has helped me with my art work . . . a painting has a right to be as exact as a joist."

Kane liked most of all to paint landscapes, but among his figures is this astonishing self-portrait. Posing himself before a mirror, he has revealed his lean, muscular, aging body with such unflinching realism and honesty that his image takes on an austere, even awe-inspiring dignity.

This is a great painting by a "common man," but a most uncommon artist.

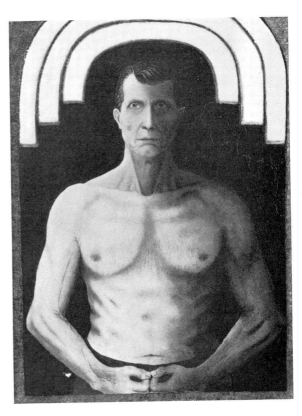

KANE: *Self Portrait*. 1929. Oil, 36⅛ x 27⅛". Museum of Modern Art, Abby Aldrich Rockefeller Fund. *John Kane*, American, born Scotland,1860-1934. To U.S.A. 1880.

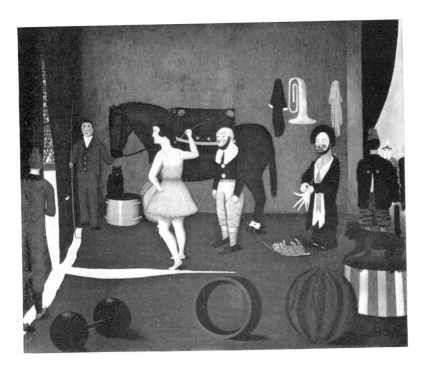

Camille Bombois began his career as a circus strong man, worked as a laborer on the Paris subway and then at a printing press. But he painted in his spare time. *Before Entering the Ring* recalls his circus days. It is completely realistic in spirit, each figure or object painted very clearly in bright colors with loving care and naive enthusiasm.

BOMBOIS: *Before Entering the Ring*. 1930-35. Oil, 23⅝ x 28¾". Museum of Modern Art, Abby Aldrich Rockefeller Fund. *Camille Bombois* (Bombwah), French, 1883-1970.

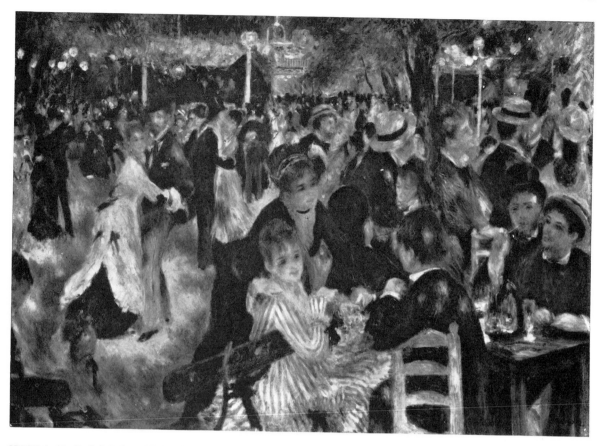

RENOIR: *Le Moulin de la Galette.* 1876. Oil, 31 x 44¾". Collection Mrs. John Hay Whitney. *Auguste Renoir (R'nwahr), French, 1841-1919.*

This is an impressionist picture and one of the masterpieces of its period. Yet when people first saw it in 1877 they thought the artist was incompetent or had bad eyesight. "When children amuse themselves with paper and colors, they do better," a critic wrote.

A century ago, in the time of President Grant and Queen Victoria and the early days of the French Third Republic, these same people would probably have understood the realism of the pictures by Eurich or Sheeler on the previous pages, but they were baffled by the impressionism of this painting by Auguste Renoir. Yet impressionism grew logically out of realism. In fact it was a kind of realism, which caught the momentary and general impression created by the shimmer of light as it falls upon a scene, especially an outdoor scene, a landscape, for instance, or a party in a café garden.

You have to see the original, or at least a color reproduction, to understand and enjoy an impressionist painting, yet even in the black and white reproduction above you can see that the forms of people, trees and chairs are all diffused in a soft mottled pattern of flickering light painted in little dabs of color without details or sharp edges or dark shadows. This naturally made people angry, for they felt the artist was cheating them of the minute details which they were used to, and they were angrier when they saw that the impressionists, instead of painting a black coat black, used green, orange, purple to make the effect more luminous.

The impressionists, taking hints from older painters such as Delacroix and using their own eyes with sensitive honesty, observed that there were no blacks in nature, since all light is colored; and furthermore that yellow sunlight creates a complementary bluish shadow. Scientists had already discovered these facts and eventually the public itself came to accept the blue shadows which once had seemed so daring.

The impressionists won a very important victory

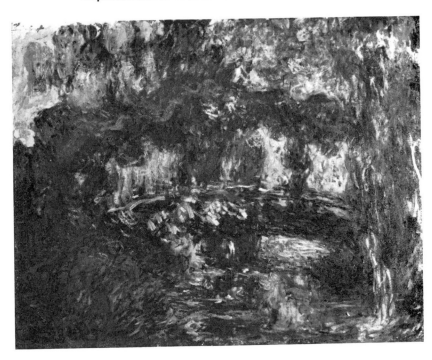

MONET: *The Japanese Foot Bridge.*
c. 1920-22. Oil, 35¼ x 45⅞".
Museum of Modern Art, Grace
Rainey Rogers Fund. *Claude Monet*
(Monay), French, 1840-1926.

by freeing themselves and, later, the public from the idea that a picture had to be a literal imitation of natural detail and color. (Whistler was fighting a similar battle in England, as we saw on page 10.)

Claude Monet, in his robust old age, carried impressionist freedom the furthest. At first glance, his *The Japanese Foot Bridge* seems nearly as far removed from nature, as abstract, as the Kandinsky or Pollock, pages 25, 43. The foreground pool, the reeds and weeping willow, the vine-covered bridge almost disappear in the overwhelming excitement of the painter's eye and hand as his brush, heavily loaded with color, swirls over the surface of the canvas. *Impressionism* here approaches expressionism.

Influenced by the impressionists, Prendergast's watercolor of a playground, *The East River*, is remarkable for its subtle color and sense of weather. Compare it with Shahn's playground picture, page 13.

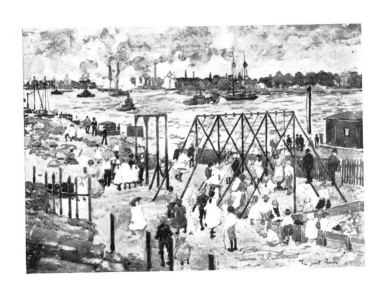

PRENDERGAST: *The East River.* 1901. Watercolor, 13¾ x 19¾". Museum of Modern Art, gift of Abby Aldrich Rockefeller. *Maurice Prendergast,* American, born Newfoundland, 1859-1924.

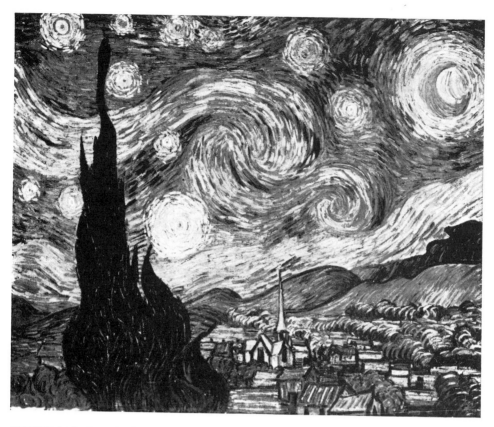

VAN GOGH: *The Starry Night.* 1889. Oil, 29 x 36¼". Museum of Modern Art, acquired through the Lillie P. Bliss Bequest. *Vincent van Gogh,* Dutch, 1853-1890. In France from 1886.

This page marks a dividing line between two general approaches to painting. The realists and impressionists are concerned primarily with the actual world which we see before our eyes. They may choose an infinite variety of subjects and these subjects they may paint literally or broadly, with pleasure in accurate facts and the thought these facts suggest. But the paintings remain essentially a record of the world outside ourselves. (Even Monet's post-impressionist *The Japanese Foot Bridge,* page 19, was probably painted outdoors with the subject right before the painter's eyes.)

We all know that there are other worlds besides this outer world of fact. There is the world of the mind, the world of the emotions, the world of the imagination, the world of the spirit. These exist within us or, at least, we know of them from internal evidence — which the artist can try to make visible and external.

The paintings on this and succeeding pages are important because they emphatically express the transforming action of these inner feelings upon the images or forms of the outer world. These paintings are actually called *expressionist,* but there are other kinds of nonrealistic paintings under various names such as cubism and surrealism. Sometimes they are hard to understand until we learn what the artist is driving at or, simply, until we get used to his art and begin to like it.

Vincent van Gogh's *Starry Night* was painted at a critical moment. For years his art had been a battle ground between fact and feeling, between the outer world of the senses, which the impressionists painted, and the inner world of emotion, which lies behind much expressionist painting. In the *Starry Night* expressionism won. The heaving line of hills, the flaming cypress trees, the milky way turned to comets, the exploding stars, all are swept into one grand, swirling, universal rhythm. Of course van Gogh did not see these things this way but he *painted* them this way,

MARIN: *Lower Manhattan.* 1920. Watercolor, 21⅞ x 26¾". Museum of Modern Art, Philip L. Goodwin Collection. *John Marin,* American, 1870-1953.

impelled by the overwhelming emotion of a man who is ecstatically aware of cosmic or divine forces. In a letter to his brother, after writing of his interest in a realistic street scene, he confessed: "That does not prevent me having a terrible need of — shall I say the word — religion. Then I go out to paint the stars . . ."

Lower Manhattan — the roar of the El, the fifty-story buildings scraping the sky — John Marin felt the excitement of the scene and he painted it — not the scene so much as his excitement — breathlessly, using great slashing, zigzag strokes — blue, scarlet and yellow —

for the angles of the buildings and even for the sky.

Listen to Living Matta calls his painting, inspired by a volcano — he was in Mexico when he painted it. But anyone who has seen a placid Mexican volcano would find this painting incomparably more volcanic. For Matta turns the world into a whirlpool of magenta pinwheels, milky vapor, sulphur and shattered jewels.

These three expressionist landscapes by van Gogh (1889), Marin (1920) and Matta (1941) make a series in which the subject is more and more completely absorbed into emotional rhythm and color.

MATTA: *Listen to Living.* 1941. Oil, 29½ x 37⅜". Museum of Modern Art, Inter-American Fund. *Matta Echaurren,* Chilean, born 1912; has worked in Paris, New York, Rome.

BECKMANN: *Departure.* 1932-33. Oil, triptych, center panel 84¾ x 45⅜"; side panels each 84¾ x 39¼". Museum of Modern Art. Max Beckmann, German, 1884-1950. Worked in Amsterdam 1936-47; in U.S.A. 1947-50.

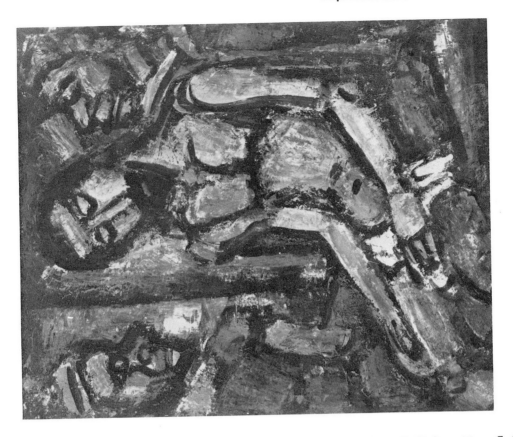

ROUAULT: *Christ Mocked by Soldiers.* 1932. Oil, 36¼ x 28½". Museum of Modern Art. Georges Rouault (Roo-oh), French, 1871-1958.

In much of the best expressionist painting, however, subject matter is important. For instance, the expressionists have succeeded in giving new life to what was centuries ago the principal concern of painters — religious art. Van Gogh, although he had turned against his church, expressed profoundly religious emotion when he painted his *Starry Night*, one of the first and greatest of modern expressionist pictures. Orozco's *Dive Bomber* (page 9) and Picasso's *Guernica* (pages 40-41), though not explicitly religious in subject, are powerful expressionist paintings by artists morally aghast at man's inhumanity.

To the right and above are religious paintings by two great expressionists. Georges Rouault was a devout Catholic, but his painting of *Christ Mocked* is not like the prettified, commercialized art which we often find in churches or shops selling sacred images. In expressing the pathos of Christ, the brutality of His persecutors, Rouault has used powerful black outlines and glowing stained-glass tones of somber red and blue. In fact Rouault as a young man had worked in a stained-glass studio and later said of himself: "my real life is back in the age of cathedrals" — an age incidentally when artists often used expressionism as a matter of course.

Max Beckmann's three-paneled painting, *Departure*, is not specifically Christian in subject, yet it is apparently an allegory of man's calvary and resurrection, his agony and liberation. Using expressionist line and color, he has painted the two side panels of torture and degradation with twisted, crowded forms and murky blacks, blood reds, and greens; for the central panel, in which the figures stand triumphantly erect and free, he has used a bright, joyful scarlet against the clear blues of sea and sky.

Beckmann was a German, blond and blue-eyed, but he decided to leave his country because of Hitler who hated modern painting.

Shortly before he left he sent *Departure* to America, labeling it on the back of the canvas "Scenes from Shakespeare's *Tempest*" in order to mislead Hitler's vigilant censorship. In Nazi Germany (as in Soviet Russia) art was less free even than religion.

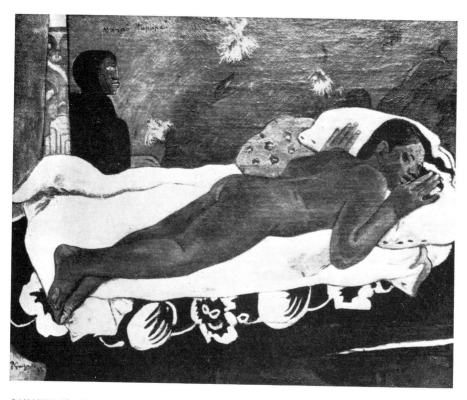

GAUGUIN: *The Spirit of the Dead Watching*. 1892. Oil, 28¾ x 36¼". Albright-Knox Art Gallery, Buffalo, A. Conger Goodyear Collection. *Paul Gauguin (Go-ga(n))*, French, 1848-1903.

We have seen in paintings by van Gogh, Marin, Orozco, Rouault and others how expressionist line and color can give a strong feeling of emotion. In their paintings the emotional effect seems appropriate to the subject and drives home its meaning. But these painters often use expressionist line and color when the subject seems to others quite calm and unemotional. Marin paints a tree in Maine with the same excitement as he pictures the turbulence of lower Manhattan; and Rouault paints flowers in the same style as a Crucifixion. In other words, *how* they paint can be separated from *what* they paint. This is true of most realists too, but with this great difference: take away the subject matter of most realists and you have comparatively little left. But the colors, shapes and lines of the expressionists have a life of their own which can survive without any subject at all.

It was Paul Gauguin, the business man turned artist and the painter of the above picture, who helped van Gogh free himself from realism. Gauguin (like Whistler) understood clearly that the de-

sign, the "form," of a picture could be beautiful in itself. He once wrote a description of *The Spirit of the Dead Watching*, one of his most famous paintings, done in the South Pacific where he had gone to escape the ugliness and materialism of civilization. After analyzing at length both the design of the painting and the subject matter, a Tahitian girl frightened by the dark figure of the spirit, he gives us this summary: "I recapitulate. The musical part: undulating horizontal lines, harmonies of orange and blue woven together with yellows and violets and lightened by greenish sparkles. The literary part: The Spirit of a Living Girl united with the Spirit of the Dead. Night and Day."

Gauguin, writing in the 1890s, uses the word "musical" because music is composed of rhythms and harmonies which can be beautiful even though they do not describe a scene or tell a story.

Many of the best and most original painters of the following generation carried these ideas further. Henri Matisse, for instance, changed the colors and

forms of nature just as much as he pleased in order to compose freely his harmonies of color and line.

Matisse wrote: "What I am after above all is expression . . . the whole arrangement of my picture is expressive . . . composition is the art of arrangement in a decorative manner . . . for the expression of what the painter wants . . ."

And then he explains what he wants: "What I dream of is an art of balance, of purity and serenity, devoid of any troubling subject matter . . . like a good armchair in which to rest from fatigue."

The Blue Window carries out his program. The line is neither dramatic like Marin's nor tortured like van Gogh's but as quiet as the subject. It is the color which counts. Most of the canvas is painted in tones of blue against which shine bright spots of green, yellow and crimson. The composition is classical: curving forms against a scaffolding of straight lines.

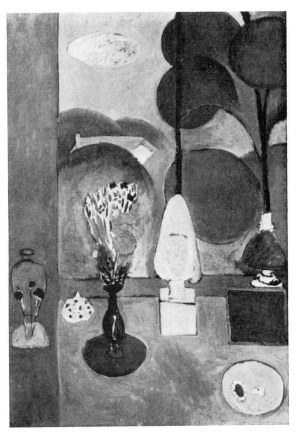

MATISSE: *The Blue Window.* 1911. Oil, 51½ x 35⅝". Museum of Modern Art, Abby Aldrich Rockefeller Fund. *Henri Matisse* (Ma-teess), French, 1869-1954.

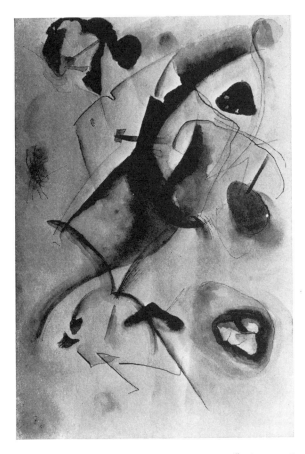

KANDINSKY: *Untitled.* 1915. Watercolor, 13¼ x 9". Museum of Modern Art, gift of Abby Aldrich Rockefeller. *Wassily Kandinsky,* Russian, 1866-1944. Worked in Germany, Russia and France.

Other painters, Kandinsky among them, turned their backs on nature entirely and painted without any subject or recognizable object at all. Kandinsky called his more important and carefully studied pictures "compositions"; his more casual pictures "improvisations." The latter, such as the delicate watercolor shown here, were done spontaneously, almost like automatic drawings or doodles. The beauty of this watercolor is intuitive rather than calculated.

Of his work Kandinsky said: "The observer must learn to look at the pictures . . . as form and color combinations . . . as a representation of *mood* and not as a representation of *objects.*"

So, within the twenty-five years covered by these three pictures, painting had reached the double goal of complete freedom and "musical" purity. But these extreme advances had involved some sacrifices both of human interest and consciously controlled design.

Gauguin and, in the next generation, Matisse and

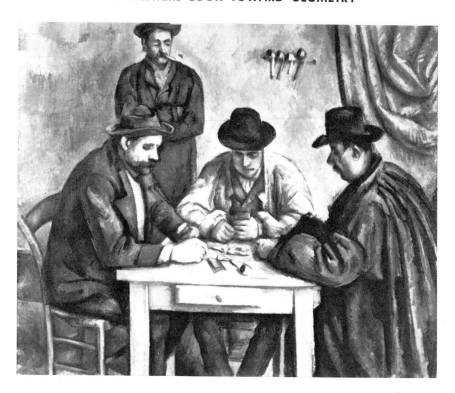

CEZANNE: *Card Players.* 1892. Oil, 25½ x 32½". Metropolitan Museum of Art, bequest of Stephen C. Clark. *Paul Cézanne* (Sayzann), French, 1839-1906.

Kandinsky sometimes spoke of their painting in terms of music, of color "harmonies" or "improvisations." But there were other artists living at the same time whose paintings suggest such terms as geometry, structure or architecture. And the architect, when he designs a building, does not need to describe a scene, depict an object or tell a story any more than does the composer of a symphony.

Ninety years ago two great masters, Paul Cézanne and Georges Seurat, led the way in this structural painting: Cézanne by a method of persistent trial and experiment; Seurat by elaborate calculation.

Cézanne had been one of the impressionists but he felt that their paintings were too flimsy and casual. He said: "I wish to make of impressionism something solid and enduring like the art of the museums," for, like most good modern artists, he had the greatest respect for the old masters.

Compare Cézanne's *Card Players* with Renoir's impressionist *Moulin de la Galette* (page 18) and you will see what he meant. Instead of a picture of

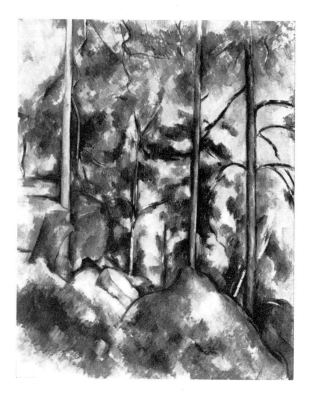

CEZANNE: *Pines and Rocks.* c. 1904. Oil, 32 x 25¾". Museum of Modern Art, the Lillie P. Bliss Collection.

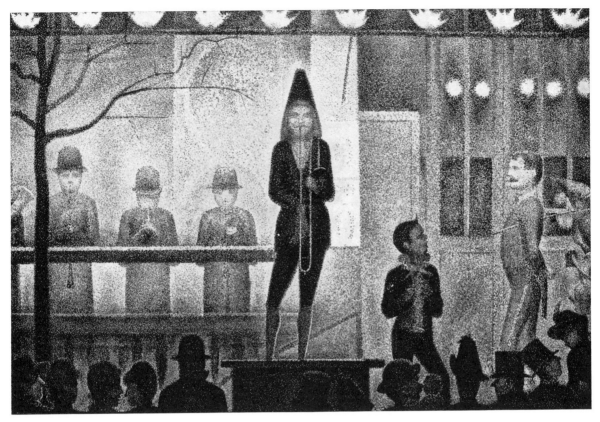

SEURAT: *Side Show*. 1887-88. Oil, 39½ x 59½". Metropolitan Museum of Art, bequest of Stephen C. Clark, Georges Seurat (Sirrah), French, 1859-1891.

flickering light and movement we find strength and gravity, the seated figures forming a kind of dome over the table while the man in the background stands firm as a tower.

Cézanne's later work is more abstract. *Pines and Rocks*, for instance, is a pattern of straight lines and angles which takes on a feeling of depth only when one has a chance to look at the picture in color. This abstract, angular pattern inspired the cubists, who also followed, at first too literally, the words of advice Cézanne once gave a young painter: "You must see in nature the cylinder, the sphere and the cone."

Like Cézanne, Seurat felt that impressionism was too haphazard and casual a way to paint, so he set out to reform it by an elaborate, systematic method. He painted in regular, round, confetti-like dots, using chiefly the six pure colors of the spectrum, and organized his canvases very carefully by working with a system of parallel lines and planes, horizontal, vertical or diagonal.

In the *Side Show* you can see how the canvas is composed with these vertical and horizontal lines broken by the figures, the tree and the row of gaslights above. This flat geometrical "organization" of planes was greatly admired twenty-five years later by the cubists and abstract painters Gris (page 29), Mondrian (page 29) and Léger (page 30).

Seurat followed his own rules with such extraordinary conscientiousness that for years after his death people were so impressed by his theories that they looked on his paintings as complicated laboratory demonstrations. Yet Seurat, perhaps in spite of his scientific system, was a great artist, whose five large compositions are today more prized than those of any other modern master.

Though different in technique and temperament, Cézanne and Seurat shared a passion for form and order and a capacity for ennobling what they painted. Cézanne's ordinary men playing cards, Seurat's fly-by-night showmen are transformed into works of art of extraordinary dignity and grandeur.

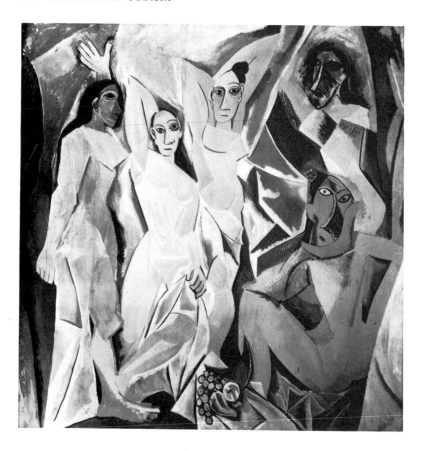

PICASSO: *Les Demoiselles d'Avignon.* 1907. Oil, 8' x 7'8". Museum of Modern Art, acquired through the Lillie P. Bliss Bequest. *Pablo Picasso,* Spanish, 1881-1973. To France in 1904.

"How could anyone paint such an ugly picture? Look at those awful faces! Do you call that art? Why, a child could do better than that. . . ."

But stop a moment: aren't we confusing the issue again? And haven't we heard the one about the child before, on page 18 to be precise? If these were real women with faces like that — especially the two at the right — no one could stand looking at them. But they are not real faces: they are areas on a painted canvas — one of the most important pioneering canvases of modern art and one of the most stirring after you understand what Picasso was about.

Let us go back to 1907, when Pablo Picasso began to paint *Les Demoiselles d'Avignon,* the first cubist picture. The most advanced younger painters were excited by Gauguin's ideas of expression through color and form (which Matisse was carrying forward) and even more by Cézanne's paintings, in which construction by lines and planes was so important. Look at the *Pine and Rocks* upside down, so that you can see the design more easily (page 26); then look back again to the above picture and you will see that

Picasso has exaggerated Cézanne's underlying pattern of angular shapes until the whole picture — figures and background — becomes a great dynamic design of zigzag lines and sharp-edged planes. The figures at the left, which were painted first, resemble certain prehistoric Spanish sculptures; the two faces at the right, which seem out of keeping with the rest, are like West African Negro masks, which interested Picasso about the time he was finishing this experimental picture. Picasso and other artists found in these primitive sculptures an art which had a strength and form of its own, free of copying nature.

Les Demoiselles is not only the first important cubist painting, it is also the first picture in which Picasso's formidable and defiant genius reveals itself. For Picasso, though he has painted many charmingly pretty pictures, is not usually concerned with "beauty" so much as with power and intensity. His art carries a high voltage.

In the years following Picasso's pioneer work, cubism passed through many phases and spread throughout the world. *The Chessboard* of Juan Gris

is a typical cubist painting of the period 1915-1920. *Les Demoiselles* was like a kind of low-relief sculpture, but *The Chessboard* is a flat pattern of almost geometrical shapes. You can easily make out the chessboard itself and the silhoutte of a table, but the other objects are scarcely recognizable.

"Why then," you may ask, "hasn't he done away with all subject matter and simply painted an abstract design without annoying us by giving it a title?" Some of the cubists eventually did just that, but most of them kept some traces of real objects in their pictures, showing that they had actually started with the image of a still life or figure or landscape, which they gradually transformed step by step into a cubist composition. For cubism is a process of breaking up, flattening out, angularizing, cutting in sections, making transparent, combining different views of the same object, changing shapes, sizes and colors until a fragment of the visual world is completely conquered and reconstructed according to the heart's desire of the artist. If you couldn't find any trace of the original subject, the key to this transformation, and our pleasure in it, would be lost.

There were many other artists who, like Mondrian, started as cubists but went further than the cubists toward an abstract art in which no trace of nature is left at all. Piet Mondrian was Dutch by birth and he loved cleanliness and fine workmanship. He liked cities with their rectangular patterns of streets, buildings, windows. The *Composition in White, Black and*

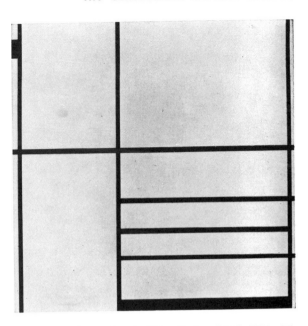

MONDRIAN: *Composition in White, Black and Red.* 1936. Oil, 40¼ x 41". Museum of Modern Art, gift of the Advisory Committee. *Piet Mondrian,* Dutch, 1872-1944. Worked in Paris 1912-14, 1919-38; in New York 1940-44.

Red, illustrated on this page, which seems so simple, took weeks to paint; for each rectangle is a different size, each black line a different thickness, and the whole is put together and adjusted to a hair's breadth with the conscience and precision of an expert engineer — though with this fundamental difference: that the engineer works for practical results, Mondrian for artistic and spiritual results — which in his case might be called the image of perfection.

Yet Mondrian, without at all intending to do so, achieved practical results to an amazing extent. His paintings have affected the design of modern architecture, posters, printing layout, linoleum, women's clothes (1965) and other things in our ordinary everyday lives. (Mondrian, by the way, was not a cold intellectual: even at seventy he loved swing music; his last completed painting is called *Broadway Boogie Woogie* and lives up to its title!)

Now look back a moment to compare again two parallel ways toward abstraction: the logical, structural, architecture-like progress which we have just followed from Cézanne and Seurat through Picasso and Gris to Mondrian; and the other path of "musical" color harmonies from Gauguin through Matisse to the spontaneous freedom of Kandinsky.

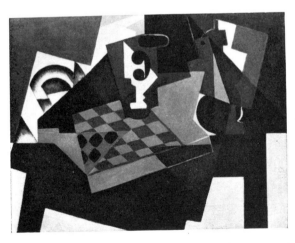

GRIS: *The Chessboard.* 1917. Oil, 28¾ x 39⅜". Museum of Modern Art. *Juan Gris* (Greese), Spanish, 1887-1927. Lived in Paris.

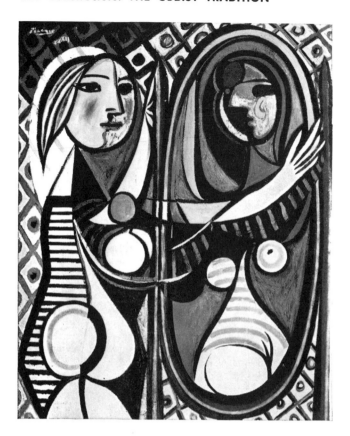

PICASSO: *Girl Before a Mirror.* 1932. Oil, 64 x 51¼".
Museum of Modern Art, gift of Mrs. Simon Guggenheim. Reproduced in color, frontispiece. *Pablo Picasso,* Spanish, 1881-1973. To France in 1904.

below: LEGER: *Three Women.* 1921. Oil, 72¼ x 99".
Museum of Modern Art, Mrs. Simon Guggenheim Fund.
Fernand Léger (Lay-zhay), French, 1881-1955.

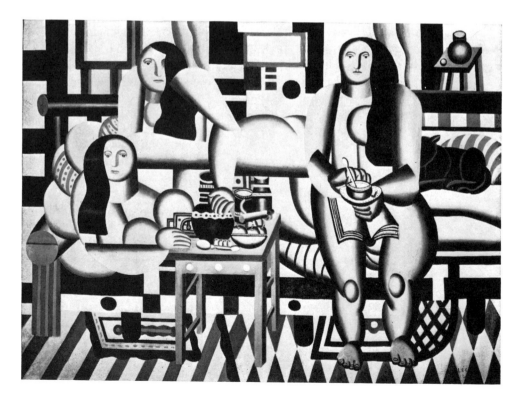

Though Mondrian and other painters reached the goal of absolute "geometrical purity" before 1920, many of the best artists kept on balancing pictorial abstraction and reality in the cubist tradition. Among them were Léger, Braque and Picasso himself.

Picasso's *Girl Before a Mirror* is like a stained-glass window (frontispiece). The intricate transformation of the girl's figure "simultaneously clothed, nude and x-rayed," and its image in the mirror, suggests philosophical speculation beyond Cubism.

The girl's head which shows both the profile and the full face, is an example of a simpler cubist practice of presenting in one picture two views of the same object which in reality we would see at different times but which in the picture we see at the same time. This introduction of a time element into an art usually considered in terms of two- or three-dimensional space suggests some relationship to Einstein's theory of relativity in which time is thought of mathematically as a fourth dimension. Such comparisons between art and science are not precise; yet there are certain interesting analogies between cubism and the space-time continuum of modern physics.

Fernand Léger combines curved and straight-edged forms in his large picture of three women seated around a breakfast table. Léger was enthusiastic about the beauty of modern machinery — pistons, crank shafts, structural steel. In his picture the shapes are drawn with the precision of a technical draughtsman, and the figures of the women are simplified into severely rounded, highly polished forms as if they too were made of metal. Indeed the design of his painting is like a great motor running smoothly on sixteen cylinders. Compare Léger's style with that of Seurat (page 27) and Sheeler (page 14).

Georges Braque's style is just the opposite of Léger's. Instead of hard metallic forms and sharp edges Braque uses soft irregular shapes. Léger lays on the paint as if he were weatherproofing a hydrant with red lead, but the surface of Braque's paint is rich and varied. Finally, Léger's colors are bright green, black and vermilion, while Braque's colors are quiet tans, greens and greys. Léger's art is strong, masculine, a little crude; Braque's restrained, tasteful, subtle. By comparing these two paintings you can see how in a cubist picture, just as in a piece of music or architecture, the character of the artist reveals itself; how every element is worked into a consistent, highly individual and personal harmony.

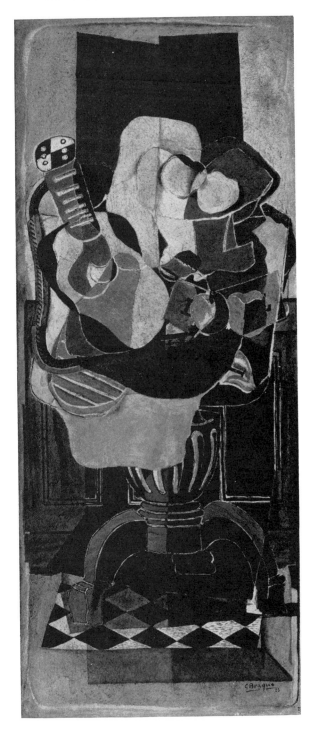

BRAQUE: *The Table.* 1928. Oil, 70¾ x 28¾". Museum of Modern Art, acquired through the Lillie P. Bliss Bequest. *Georges Braque,* French, 1882-1963.

Artists used to suggest movement by a figure in a single fixed attitude or, sometimes, several figures, runners for instance, in different positions, all presumably true to what one could see at a single instant of time.

Balla, in his ingenious *Dynamism of a Dog on a Leash,* broke this convention. For this Italian Futurist a running dachshund has not four but forty legs. Today we are used to this effect through seeing stroboscopic photographs of dancers or leaping young ladies advertising lastex girdles, but in 1912 it seemed revolutionary.

Marcel Duchamp was not a Futurist but his *Nude Descending a Staircase,* like Balla's *Dog,* attacks the problem of motion though in a more complex fashion. Duchamp's *Nude* develops a multiple body as well as multiple limbs as she moves down the steps. The staircase itself seems broken into fragments as it too changes shape and position in relation to the moving figure. Thus motion in space-time is analyzed in terms of space alone but the analysis is artistic, not scientific, photographic or metaphysical.

When the *Nude Descending a Staircase* was first shown in America it was described by an outraged critic as "an explosion in a shingle factory." That was in 1913. Today it is considered a masterpiece of 20th-century painting.

The Italian Futurists of 1912, Balla among them, were concerned not only with painting motion but also with the dynamics of modern life. A speeding automobile, they held, is more beautiful than the *Winged Victory.* Boccioni, their leader, even at-

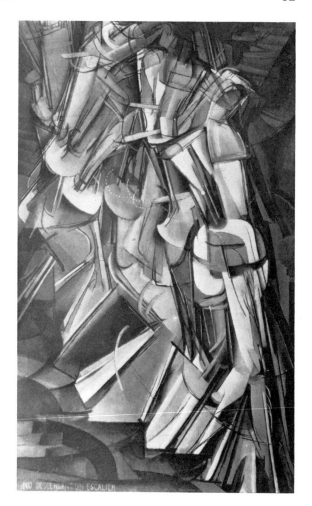

DUCHAMP: *Nude Descending a Staircase.* 1912. 58⅜ x 35⅜". Philadelphia Museum of Art, The Louise and Walter Arensberg Collection. *Marcel Duchamp,* American, born France, 1887-1968. In U.S.A. 1915-18, 1920-23, 1942-68.

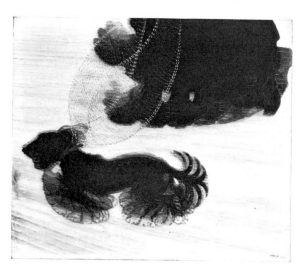

tempted to paint the psychological effect of modern noise, speed and general commotion upon the individual — for example his *States of Mind,* opposite. In this three-part composition the abstract linear design of each canvas reinforces its particular mood.

BALLA: *Dynamism of a Dog on a Leash.* 1912. Oil, 35¾ x 43⅜". Albright-Knox Art Gallery, Buffalo, A. Conger Goodyear Collection. *Giacomo Balla,* Italian, 1871-1958.

BOCCIONI: *States of Mind.* 1911. Three oils, each 27⅛ x 37⅜". Museum of Modern Art, gift of Nelson A. Rockefeller. *Umberto Boccioni* (Botchónee), Italian, 1882-1916.

I, The Farewells. The hurly-burly of the railroad station; people bustling, embracing, saying good-bye; the locomotive puffing, etc.

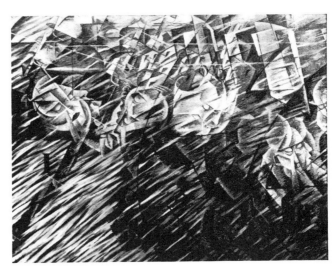

II, Those Who Go. The sleeping faces of travelers in their train compartment as they rattle along the track; the houses and telegraph poles whisking by; the stenciled numerals of the I and III class compartments.

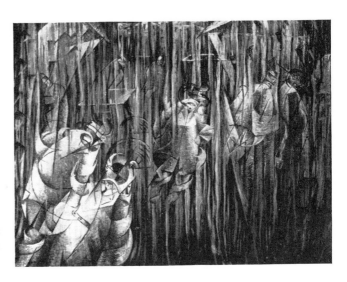

III, Those Who Stay. Their dejection as they walk away from the station following the excitement of leave-taking.

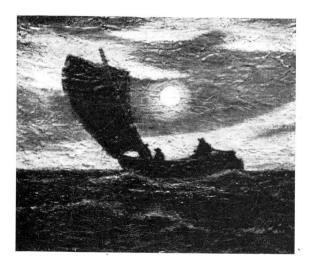

The realists were concerned with visual facts and their connotations; the impressionists with effects of light; the expressionists with the emotional or decorative distortion of natural shapes and colors, sometimes eliminating objects entirely in favor of "musical" color; the futurists with movement; the cubists with transforming natural images into compositions of angular planes which in the work of certain followers became abstract geometric designs; but, after you've taken a deep breath, there is still another kind of painting which is very old but which

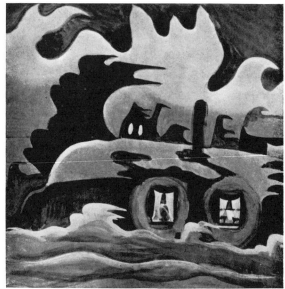

above: RYDER: *Toilers of the Sea.* Completed about 1900. Oil, 10 x 12". Addison Gallery of American Art, Andover, Mass. *Albert Pinkham Ryder,* American, 1847-1917.

right: BURCHFIELD: *The Night Wind.* 1918. Watercolor, 21½ x 21⅞". Museum of Modern Art, gift of A. Conger Goodyear. *Charles E. Burchfield,* American, 1893-1967.

below: GRAVES: *Snake and Moon.* 1938-39. Gouache and watercolor, 25½ x 30¼". Museum of Modern Art. *Morris Graves,* American, born 1910.

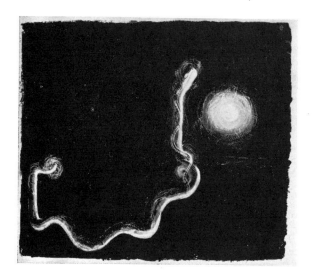

modern artists have explored with enthusiasm during recent years. These works have no generally accepted name: some of them are called romantic and some surrealist. Their appearance is confusing because many techniques are used, from almost abstract to photographically realistic. But they have one important factor in common, for they are born of the poetic imagination and their effects are poetic in the broad sense of the word, no matter what techniques are used. Of course there is some poetry in most of the paintings we have reproduced in this book — in fact a great deal in van Gogh's *Starry*

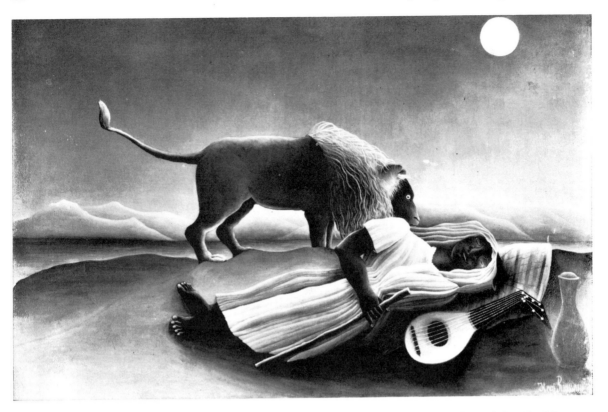

ROUSSEAU: *The Sleeping Gypsy.* 1897. Oil, 51 x 79". Museum of Modern Art, gift of Mrs. Simon Guggenheim. *Henri Rousseau, French, 1844-1910.*

Night or Dove's *Grandmother* — and these pictures might well be included here if they had not already been illustrated. But on this and the following few pages the poetic quality is more intense — or, at least, more intentional. Instead of depending on description like the realists, direct emotional effects like the expressionists, or formal invention like the cubists, these artists evoke our love of the mysterious and romantic, the strange and astonishing, the dreamlike.

Night is the mother of mysteries, as these four paintings affirm. Albert Ryder was the great American poet of the night and the chief master of romantic painting in this country. With a dark sail, the moon above and the heaving sea beneath he makes a picture of deep and simple poetry.

Painting seventy years ago, Ryder used a fairly realistic technique, but Charles Burchfield's *Night Wind* is painted with a naive expressionism, evoking a memory of his own childhood: "To the child sitting cozily in his home the roar of the wind outside fills his mind full of strange visions and phantoms flying over the land." Morris Graves' snake quivers in an ecstatic lunar dance.

One of the great night pictures in all art is Rousseau's *Sleeping Gypsy.* Though it was painted by a simple, self-taught artist its mystery is complex. Beside a sleeping figure in a striped coat with a jug and lute stands a stiff, almost comic lion. At first glance the picture seems both solemn and absurd. But if you study it its fascination grows until it casts a spell — like the memory of an enigmatic but important dream.

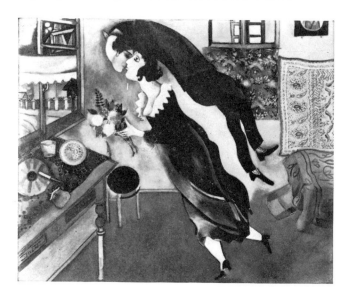

It is again the atmosphere of the dream which Chagall, de Chirico and Dali create. In the paintings on this page they make the impossible seem actual by means of realistic technique, psychological intuition and poetic conviction.

A couple of weeks before their marriage Chagall's fiancée visited his studio — it was his birthday, the artist remembers, July 7, 1915. Immediately afterwards he painted a vision of their meeting: she, giddily tripping forward with the flowers she had brought him; he, lifted bodily high in the air as he turns and twists to kiss her. Chagall seems to be saying: "All's fair in art as well as in love."

above: CHAGALL: *Birthday.* 1915. Oil on cardboard, 31¾ x 39¼". Museum of Modern Art, acquired through the Lillie P. Bliss Bequest. *Marc Chagall* (Shagal), French, born Russia, 1889-1985.

right: DE CHIRICO: *The Anxious Journey.* 1913. Oil, 29¼ x 42". Museum of Modern Art, acquired through the Lillie P. Bliss Bequest. *Giorgio de Chirico* (Kee-ree-ko), Italian, born Greece, 1888-1978. Worked in Paris.

below: DALI: *The Persistence of Memory.* 1931. Oil, 9½ x 13". Museum of Modern Art. *Salvador Dali* (Dahlee), Spanish, born 1904. Worked in Paris and New York.

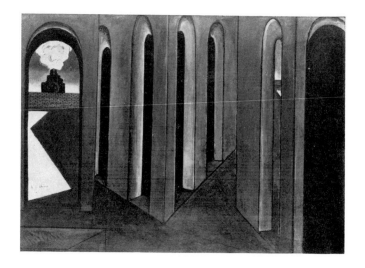

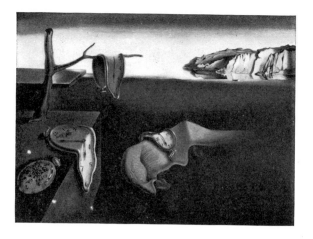

There are bad dreams too. De Chirico's *Anxious Journey* presents us with a nightmare railroad station as empty as Boccioni's is bustling (page 33). We see two corridors: one leads up a ramp far too steep for comfort towards a remote impassable barrier; the other, to the left, conducts us among sinister shadows to a gateless brick wall behind which puffs an inaccessible locomotive. Will our anxiety and frustration harry us through the tall arch at the right into the black and floorless void?

Chagall and de Chirico were painting their poetic hallucinations a dozen years before the surrealist artists of whom Salvador Dali was the most con-

spicuous. About such pictures as his *Persistence of Memory* Dali has written: "I am the first to be surprised and often terrified by the images I see appear upon my canvas. I register without choice and with all possible exactitude the dictates of my subconscious, my dreams—the manifestations of that obscure world discovered by Freud, one of the most important discoveries of our epoch, reaching to the most profound and vital roots of the human spirit." Such images, he maintains, are appreciated by our own subconscious even when we protest with our conscious minds that we do not understand them. Perhaps Dali is right, for this picture of limp watches is so renowned partly because it is unforgettable.

The limp watches are irrational, impossible, fantastic, paradoxical, disquieting, baffling, alarming, hypnogogic, nonsensical and mad — but to the surrealist these adjectives are the highest praise. The surrealists believe that the subconscious is the source of all that is valuable in art — and their painting and poetry and sometimes their conduct express this belief.

Dali called his paintings "hand-done color snapshots" for he has used a meticulously exact realism — a magic realism — to make convincing his fantastic images. But other surrealist painters use just the opposite technique. Like the extreme expressionists they turned the hand — as well as the imagination — loose upon the canvas, creating images with reckless spontaneity. Joan Miró's *Person Throwing a Stone at a Bird* is semi-automatic in conception, like the Kandinsky (page 25) or the Matta (page 21).

In Paul Klee's *Around the Fish* the bright magic symbols are so vividly imagined and so mysteriously related to each other that they suggest some secret incantation.

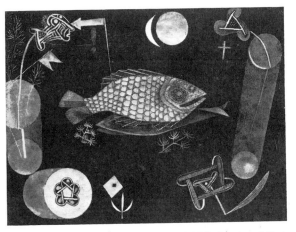

KLEE: *Around the Fish*. 1926. Oil, 18⅜ x 25⅛". Museum of Modern Art, Abby Aldrich Rockefeller Fund. *Paul Klee* (Clay), German, 1879-1940. Born and died in Switzerland.

ERNST: *The Hat Makes the Man*. 1920. Collage, pencil, ink, watercolor, 14 x 18". Museum of Modern Art, Purchase. *Max Ernst*, French, born Germany, 1891-1976. To France 1922; in U.S.A. 1941-50.

"The hat makes the man" mocks human gullibility. Max Ernst mocks the proverb itself by taking its irony literally. Hats make his four absurd men, twenty-six commonplace hats cut out of a mail-order catalogue. Both technique (collage or pasting) and cynical, antirational wit are typical of Dadaism which flourished around the end of that colossal madness, World War I. Dada has recently revived; its spirit is lively in the art of today.

MIRO: *Person Throwing a Stone at a Bird*. 1926. Oil, 29 x 36¼". Museum of Modern Art. Joan Miró (Meero), Spanish, 1893-1983. Worked in Paris.

BLUME: *The Eternal City.* 1934-37. Oil, 34 x 47⅞". Museum of Modern Art, Mrs. Simon Guggenheim Fund. *Peter Blume,* American, born Russia 1906. To U.S.A. 1911.

Of course poetry and fantasy are not the only valuable qualities of the paintings reproduced on the past few pages. The richness of Ryder's paint surfaces, the color of Chagall and Miró, the clean-cut design of Burchfield and Klee, Dali's technical virtuosity are important too. But in all writing about paintings — and in looking at them, too — it is hard to keep more than one or two qualities of a picture in mind at once.

Certain paintings are far more complex than others; they may involve various layers of meaning and numerous associations drawn from history, religion or mythology; and these may in turn imply symbolism and allegory. Some of the greatest (and some of the worst) works of the past displayed this elaborate character and so do the ambitious paintings now to be considered.

Most modern artists paint a dozen or two dozen canvases a year, some good, others mediocre. But rarely does a painter concentrate all his powers upon a single important work, which, if it turns out well, may be called a masterpiece. Such a picture takes courage, for it often consumes a great deal of time and hard work with little assurance of any return, unless the painting has been commissioned beforehand.

In 1932 the young American artist, Peter Blume,

visited Italy, and after a six months' stay came back determined to put what he had seen and felt and thought into one large canvas. Five years later his picture, *The Eternal City*, was finished: it had been put together slowly and painted with detail as minute as that of certain Italian and Flemish fifteenth-century pictures which the artist admired, although earlier in his career he had been a cubist and painter of abstract compositions.

The name, *The Eternal City*, refers of course to Rome, but in the picture the artist has brought together scenes from many periods and places. Nearby at the left a beggar woman sits among the fragments of a statue of lovers. Behind her is a shrine with a figure of Christ, the Man of Sorrow, surrounded by jewels and swords, symbols of vanity and force. Out of the catacombs in the center the people are clambering up into the light of the Roman Forum, where they are met and beaten by Fascist officers. Over these scenes of violence, beauty and decay, scowls the collapsible, jack-in-the-box head of Mussolini. This head is a bright, acid green and sticks out of the picture like a sore thumb. It is ugly, out of key in color, out of scale in design; but that is just the effect the artist wanted, to make clear how he felt about Mussolini — years before Mussolini collapsed.

Like so many original and challenging paintings of the past hundred years *The Eternal City* was attacked on all sides when it was first shown in 1937. Some critics disliked its precise realistic technique and its elaborate use of symbolism and allegory; others attacked it because they felt art should have nothing to do with social and political questions; and many of course condemned the "inartistic" jack-in-the-box. In fact, the picture was twice excluded from exhibitions.

The Eternal City is an important incident in one of the revolutionary returns to subject interests which began in painting a little before World War I with such artists as de Chirico, Picasso and Chagall and gained great headway by 1920. Art is always in a state of revolution, sometimes gradual, sometimes sudden. And, just as in politics, revolutionary ideas in art, after they are generally accepted, become a part of conservative opinion which in turn tries to defend itself against a new revolution.

Whistler in 1875 was revolutionary in asking the public to regard his pictures as "arrangements"

without paying any attention to the subject. Kandinsky carried similar ideas to a climax about 1912 by leaving out subject matter entirely and telling us to look at pictures purely "as form and color combinations" (pages 10, 25).

Similarly, Whistler was attacked because he once painted a picture in only two days. Kandinsky's watercolor *Improvisation* probably took less than an hour. Both artists attached great value to rapid, spontaneous technique. And, as a corollary, Whistler, Gauguin, Matisse, Picasso, all painted with broad, simple planes of color (pages 10, 24, 25, 28).

By 1935, among people interested in art, these ideas of simplicity, spontaneity and artistic purity were no longer revolutionary. In fact they had become so orthodox and academic that they had considerably influenced our school and college teaching.

Therefore, when Peter Blume painted a picture which not only had a subject, but a subject of great and controversial importance, and when he painted this not broadly and simply in a few hours or a few days but with such elaborate intricacy that it took him several years, it is scarcely surprising that the devotees of the earlier "form and color" revolution were upset and muttered the words "reactionary" or "it isn't art" (much as they had about Dali's surrealist realism, page 36, and Grant Wood's satirical realism of 1930, page 16, or Picasso's classical realism of 1920).

The Mexican mural painters, such as Orozco and Rivera, followed by numerous Americans, had preceded Blume by many years in reviving the elaborate allegory with historical, social and political subject matter. Blume, however, concentrating within the smaller scale of the easel painting, brought the allegory to a more incisive, sharper focus.

In the same year that Blume finished his *Eternal City* another artist of far greater fame had his say about the Axis. On April 28, 1937, the ancient and hallowed Spanish town of Guernica was bombed by German planes flying for General Franco. The *Luftwaffe* was said to have been satisfied with the night's work: about a thousand people — one out of eight — were killed. It was the first "total" air raid.

Two days later the Spaniard, Picasso, took an artist's revenge; he began work on his *Guernica,* a huge mural canvas nearly twenty-six feet long, commissioned by the Republican Government for the Spanish building at the Paris World's Fair.

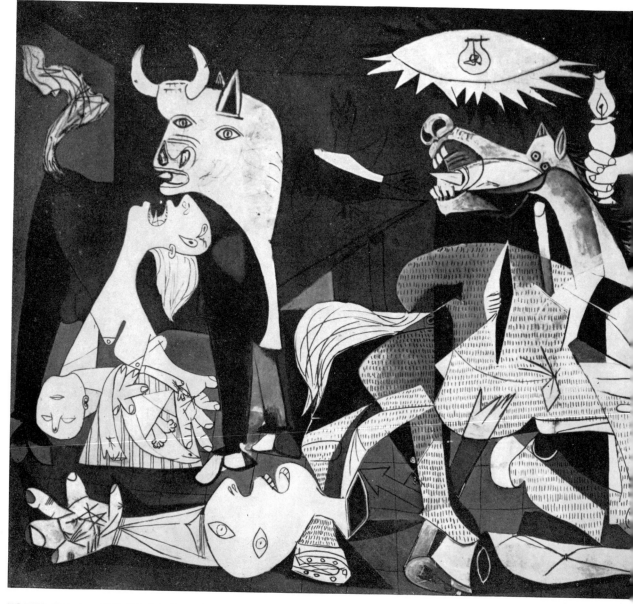

PICASSO: *Guernica*. 1937. Oil, 11′ 5½ x 25′ 5¾″. Prado Museum, Madrid, gift of the artist. *Pablo Picasso*, Spanish, 1881-1973. To France in 1904.

The artist has given no exact explanation of *Guernica* beyond declaring that it is an attack upon "brutality and darkness." At the far right of a stage-like space a woman, her clothes on fire, falls shrieking from a burning house, while another rushes in toward the center of the picture, her arms flung wide in despair. At the left is a mother with a dead child in her arms, and on the ground are the fragments of a sculptured warrior, one hand clutching a broken sword from which springs a flower. In the center a dying horse sinks to his knees, his screaming head flung back, his back pierced by a spear. To his left is a bird and then a formidable bull staring out of the scene. Over all shines a radiant eye with an electric bulb for a pupil. Beneath it to the right a figure leans from a window as she bears witness to the carnage, one hand is clutched to her breast, the other holds the lamp of truth.

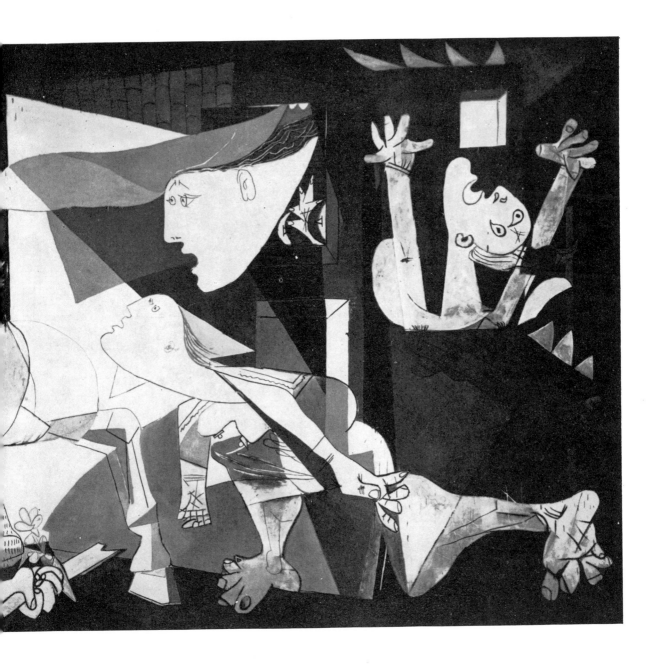

In painting *Guernica* Picasso used only black, white and grey, the grim colors of mourning. But otherwise he has made full use of the special weapons of modern art which during the previous thirty years he himself had helped to sharpen: the free distortions of expressionist drawing, the angular design and overlapping transparent planes of cubism, surrealist freedom in the use of shocking or astonishing subject matter. Picasso employed these modern techniques not merely to express his mastery of form or some personal and private emotion but to proclaim publicly through his art his horror and fury over the barbarous catastrophe which had destroyed his fellow countrymen in Guernica — and which was soon to blast his fellow men in Warsaw, Rotterdam, London, Coventry, Chungking, Sebastopol, Pearl Harbor and then, in retribution, Hamburg, Milan, Tokyo, Berlin, Dresden, Hiroshima.

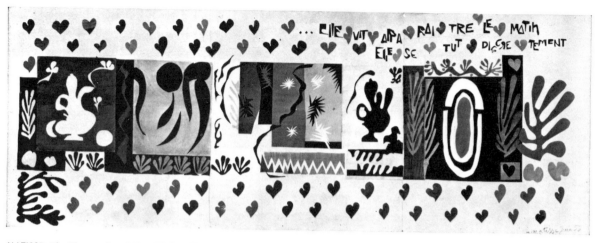

MATISSE: *The Thousand and One Nights.* 1950. Gouache on cut-and-pasted paper, 57" x 12' 6½". Museum of Art, Carnegie Institute, Pittsburgh. *Henri Matisse* (Ma-teess), French, 1869-1954. The lettering, in French, gives the concluding sentence of the *Arabian Nights*: "She saw morning appear. Discreetly she fell silent."

The ominous prophecies of Orozco, Beckmann, Blume, Picasso (pages 9, 22, 38, 40-41) were fulfilled during World War II. After the war, painters in general turned away from destruction and horror. As before, they painted in a great many different ways but, looking around one, it was clear that abstract painting was the dominant, characteristic art of the mid-century. (That is, in the free world. Painters controlled by the Communists, however, are enjoined to use a realistic style though, of course, this does not mean that "realistic" painters, in America for instance, are ordinarily Communist in sympathy!)

Abstract painting in the past ranged from Kandinsky's free improvisation, page 25, to Mondrian's precisely constructed *Composition*, page 29. Post-World-War-II abstract painting has been enriched by an even greater variety of style and much vigorous new talent.

Old talent, too, for Matisse, leader of the oldest generation of French artists, in his last years did his most abstract work. His *1001 Nights* is a series or frieze of episodes composed with scissor-cut forms in brilliant colors. The forms (except the inscription) have little obvious relation to the Arabian nights — less, for instance, than Rimsky-Korsakov's *Scheherazade* music. Matisse's stories are entertainment for the eye alone — gay, witty, bright as flowers or fireworks.

Gorky's *Agony* is equally abstract but the very opposite in mood. From an interior of dark murky brown emerge smouldering red pulsations barbed with color and lit by a towering flame of white. Thus, at the end of his life, the artist's pain, both physical and spiritual, was transmuted into art.

Without the title *Agony* how, you may ask, would we know what this almost abstract picture expressed? The answer is, of course, that we would not: yet without their titles such comparatively realistic paintings as the *Withdrawal from Dunkirk*, page 8, or *Christ Mocked*, page 23, would also be less meaningful though scarcely less beautiful.

GORKY: *Agony.* 1947. Oil, 40 x 50½". Museum of Modern Art. A. Conger Goodyear Fund. *Arshile Gorky.* American, born Turkish-Armenia, 1904-1948. To U.S.A. 1920.

How expressively varied in character abstract paint-ing can be is further proven by ·the two very large paintings on this page. Pollock's *Number 7* suggests a frieze but, unlike Matisse, Pollock composed his frieze in three complex linear rhythms which play across the entire width of the canvas. The first of these is a "bass" or background theme painted with a broad brush. Over this swing and leap in synco-pated counterpart two staccato themes, one white, one black, both of them produced by letting the paint drip and spatter as the artist's arm moved rhythmically above the canvas laid flat on the floor.

Thus Pollock's *Number 7* is a painting of movement but unlike Balla's *Dog* or Duchamp's *Nude* (page32) it is a direct visual recording of movement, the very motion of the artist's hand and arm.

In both the Matisse and the Pollock the *surface* of the picture is emphasized by pasting paper or drip-ping paint upon it, but in Rothko's *Number 10* the surface of the canvas seems almost to have dis-appeared. Instead, mists of color, white, violet blue, golden yellow, pale grey, seem to float over it like impalpable translucent blinds drawn, one upon an-other, down over a magic window. The large size of this painting, its quiet horizontals, broad, muted tones, evanescent surfaces and subtle edges combine to create an effect of immanent serenity and silence.

Upon those who liked them, Whistler's nocturnes of eighty years ago may have had a somewhat similar effect — though Ruskin's famous charge, page 10, that Whistler (that "Yankee coxcomb") was "flinging a pot of paint in the public's face" would seem to apply more to Pollock than to Rothko. Yet both these Americans of today have created new kinds of beauty; and both, like Whistler and most of the other painters in this book, have had to suffer for their courageous achievements before our eyes have been opened and we have learned to see.

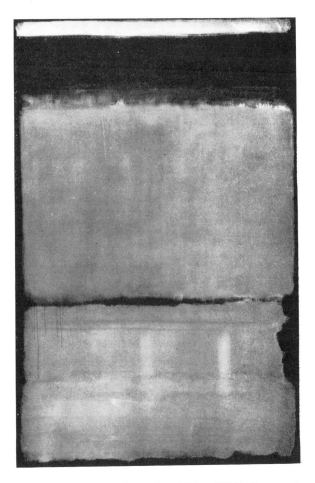

ROTHKO: *Number 10.* 1950. Oil, 90⅜ x 57⅛". Museum of Modern Art, gift of Philip C. Johnson. Mark Rothko, born Latvia 1903-1970. To U.S.A. 1913.

POLLOCK: *Number 7.* 1950. Oil, 24" x 8' 10". Collection Mr. and Mrs. Joseph Slifka, New York. *Jackson Pollock,* American, 1912-1956.

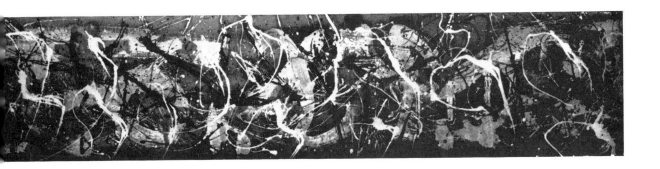

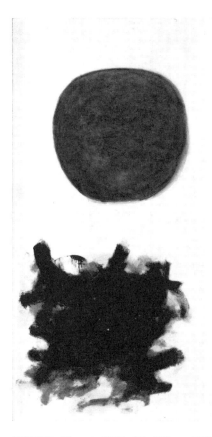

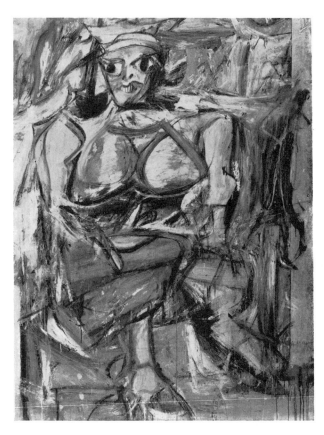

GOTTLIEB: *Blast, I.* 1957. Oil, 90⅛ x 45⅛".
Museum of Modern Art, Philip Johnson Fund.
Adolph Gottlieb, American, 1903-1974.

DE KOONING: *Woman, I.* 1950-52. Oil, 75⅞ x 58". Museum of
Modern Art. *Willem de Kooning,* American, born The Netherlands
1904. To New York in 1926.

Gottlieb's *Blast, I* is easy to describe: the background is pure white; the disc is deep luminous red; the irregular, blurred form below is sooty black. The contrasts are violent, form against form, color against color. But the painter insists: "The idea that a painting is merely an arrangement of lines, colors and forms is boring." *Blast!* Does the red disc suggest apocalyptic doom glowing over the world's charred ruins? Is this a succinct 1957 version of *Guernica?* Don't jump to conclusions — the disc may be the rising sun. Besides, in other similar paintings by Gottlieb the disc is a gentle green. *Blast, I* is ambiguous. Its "meaning" depends in part on you — and that accounts for some of its fascination. "When we are solemnly advised . . . to be humanists or to go back to nature, who listens seriously to this whistling in the dark?" Not Gottlieb, for, essentially, he turns his back upon neither humanity nor nature.

Willem de Kooning goes "back to nature" whenever he wants to. His formidable *Woman, I* seems both frightening and frightened. Painted with expressionist fury, it matches the passionate intensity of van Gogh's *Starry Night,* p. 20, or Beckmann's *Departure,* p. 22. De Kooning once remarked: "I do not think . . . of art in general as a situation of comfort."

Inevitably many young painters rebelled against the abstract expressionism of Gorky, Pollock, Rothko, Gottlieb, de Kooning and others. Some turned to traditional figure painting, some painted clean-cut abstractions. Others, influenced by Marcel Duchamp, revived the Dada spirit (see p. 37) not only through painting but in paperpasting (collage) and "junk" sculpture (assemblage). There is some Dada, too, in the most conspicuous new movement, Pop Art.

LICHTENSTEIN: *Flatten—Sand Fleas!* 1962. Synthetic polymer paint and oil, 34⅛ x 44⅛". Collection Mr. and Mrs. Enrico Carimati, Milan. *Roy Lichtenstein, American, born 1923.*

Pop artists have explored the American scene in all its democratic, mass-produced banality and have extended the subject matter of art by including hot dogs, pin-up girls, ice cream cones, automobile crashes, Elvis Presley, billboards, pop bottles, comic strips and fifty identical soup cans. Their art is deadpan, "cool," and even when the artists are ironic, they dignify their subjects by painting them.

"Flatten — Sand Fleas!" was originally an exclamatory "comic" book incident of U. S. Marines landing on a beach. Lichtenstein found it interesting and made it more so by greatly enlarging it and sharpening somewhat its composition and detail. In character and quality of violence compare it with de Kooning's *Woman, I* and Picasso's *Guernica*, page 40.

SCHMIDT: *Untitled.* 1965. Synthetic polymer paint, 48⅛ x 96⅛". Museum of Modern Art, gift of Mr. and Mrs. Herbert C. Bernard. *Arnold Schmidt, American, born 1930.*

Never have art movements suffered shorter labels than Pop Art and Op Art and never have they differed more radically. Much "optical" painting depends on color but Arnold Schmidt's composition is an austere, hard-edge abstraction in black and white. Moreover, the forms are so arranged that *optically* the two white areas seem to recede in space and, at the same time, seem brilliantly radiant, thereby suggesting in an eight-foot wide painting an almost architectural effect of perspective and dazzling light.

Conclusion: Which Are the Great Paintings?

The recent abstract paintings of Matisse and Rothko (pages 42, 43) seem far removed from Picasso's *Guernica* of 1937 (page 40); and the *Guernica* itself is a far cry from Picasso's *Demoiselles d'Avignon* of 1907 (page 28), though not so much in general appearance as in subject matter, meaning and purpose. The *Guernica* is a dramatic statement about one of the world's most urgent problems: war and its effect on humanity. It refers to great happenings outside the picture. Although the *Demoiselles* is powerful in spirit and composition, a pictorial "sock in the eye," and although it is possibly the most important painting of its period, its explicit meaning in relation to the state of the world is very limited.

And this is true of most of the great paintings of the past hundred years. Look again at Renoir's *Moulin de la Galette,* painted in 1876 (page 18), Seurat's *Side Show,* 1887-88 (page 27), Cézanne's *Card Players,* 1892 (page 26), Matisse's *Blue Window* of 1911 (page 25) and Léger's *Three Women* of 1921 (page 30). From the Renoir to the Léger these pictures seem rather simple in conception and meaning; almost their whole interest lies in what we can see before us, and what we see is above all a beauty of form and color with little obvious interest in human emotion or character and even less in religion, politics, economics, psychology or the historical and mythological past of the human race. These older paintings are victories in a long war of independence during which artists fought to free art first from subservience to the complex world of human affairs, past and present, and then from visual reality itself — until the abstract purity of Kandinsky (page 25) and Mondrian (page 29) was achieved. This was a heroic struggle which we should not un-

derestimate, for it brought to light many new forms and techniques and created a treasury of paintings which appeal directly to the eyes, to our sense of visual order or freedom, serenity or excitement. Renewed exploration is once more in progress.

But the works characteristic of the period 1935-1940 step boldly outside the realm of form and color. Blume's *The Eternal City* (page 38) reveals with patient prophetic clarity the hollow pomposity and corruption of a dictator's power. Beckmann's *Departure* (page 22) suggests the liberation of Europe from Nazi sadism. Picasso's *Guernica* and Orozco's *Dive Bomber and Tank* (page 9) show us the impact of war upon the defenseless civilian or the machine-mangled soldier. Yet these are not superficial propaganda pictures, painted to enlist recruits or flatter a Nazi or Soviet dictatorship. They are the work of free men profoundly moved by great and terrible events and eager to tell the truth about them with all the resources of modern painting.

Does this mean that paintings such as these are the greatest of our time? Not necessarily. There may be other recent paintings which twenty years from now will seem obviously greater. We cannot tell for sure. Nor can we say that these paintings for all their power and richness of interest are better than the best paintings of several decades ago. In fact it is quite probable that a poll on the question as to which are the greatest pictures reproduced in this book would reveal that both the public and the experts prefer the Renoir, the Ryder, the van Gogh, the Rousseau, the Seurat, the Cézanne, the Picasso *Demoiselles,* and the Matisse more than the Beckmann, the Orozco, the Blume and the Picasso *Guernica.* Why? There are several reasons. There is the factor of time and the change of opinion which time brings about. The first group are older and their fame well established. The critics who once assailed them are almost all dead; and, since the reaction against their success has not yet grown strong, such artists as van Gogh and Cézanne may now be at the peak of their fame. Or it may be that the times are ripe for one kind of painting and not for another.

And then there is the factor of quality. The greatness of a painting does not depend upon its ambitious scale, the importance of its subject, nor upon its "human interest" and emotional content, nor yet upon its fine design and color. Any one of these factors may contribute towards a painting's value.

If all are present, so much the better, but even that total will not necessarily make a great painting. Indeed, they may all be added together to form a faultless but mediocre and tedious work.

Excellence in a work of art is not a matter of accumulation or quantity but of the *quality* of the work as a whole; and quality is relative: it cannot be measured or proved or even analyzed with any logical satisfaction. As Renoir once remarked, "If you can explain a painting, it isn't a work of art." For in the end what makes a great work of art great is always something of a mystery.

Truth, Freedom, Perfection

Truth, freedom, perfection: let us think again about these three words with which the introduction to this booklet closed — words which might be proposed as the artist's equivalent of what liberty, equality, fraternity were to the French Revolution, or, in a somewhat different sense, what faith, hope and charity are to the Christian.

"War is hell!" This truth uttered by General Sherman, our nineteenth-century master of total war, has rung loud in recent years. A critic trying to make fun of Picasso's *Guernica* tells how a soldier standing before the canvas, remarked, "I wonder what Sherman would have said about Picasso." Out of occupied Paris came another story about the *Guernica.* The Germans, the legend tells, so valued the prestige of winning great foreign artists to their side that they sent their agent, Otto Abetz, to Picasso to persuade him to make a trip to Berlin as a friendly gesture toward the Nazis. Picasso refused curtly. On his way out of the studio the embarrassed German noticed a photograph of the *Guernica* and, forgetting the *Luftwaffe's* role in the picture said: "Ah, Monsieur Picasso, so it was you who did that." "No, Herr Abetz," replied Picasso, "you did."

Sherman in words, Picasso in paint were telling the same truth, each in his own language. Just as Picasso's forms are not to be found in nature, Sherman's "hell" is unknown to science. Indeed those who insist on facts will have to forgive the General his figure of speech, remembering that by his metaphor he won perhaps wider and more lasting fame than by his sword.

The truth which plumbs deeply, convinces the mind, brings joy to the heart or makes the blood

run chill is not always factual; indeed it is rarely to be found in newsreels, statistics or communiqués. The soothsayer, that is, the truth-sayer, the oracle, the prophet, the poet, the artist, often speak in language which is not matter-of-fact or scientific. They prefer the allegory, the riddle, the parable, the metaphor, the myth, the dream, for, to use Picasso's words, "Art is a lie that makes us realize the truth."

In order to tell this truth the artist must live and work in *freedom*. President Roosevelt, with the totalitarian countries in mind, put it clearly. "The arts cannot thrive except where men are free to be themselves and to be in charge of the discipline of their own energies and ardors. . . . What we call liberty in politics results in freedom in the arts. . . . Crush individuality in the arts and you crush art as well."*

Sometimes in art galleries one hears a man who has just glanced at a cubist or expressionist picture turn away with the angry words, "It ought to be burned," or "There ought to be a law against it." That was just the way Hitler felt. When he became dictator he passed laws against modern art, called it degenerate, foreign, Jewish, international, Bolshevik; forced modern artists such as Klee, Kandinsky, Beckmann (pages 37, 25, 22) out of art schools, drove them from the country and snatched their pictures from museum walls, to burn them or sell them abroad. (The Klee, on page 37, used to hang in the Dresden museum, the Matisse, on page 25, in the Essen museum, until Hitler had them removed.)

Similarly the Soviet authorities, even earlier than the Nazis, began to suppress modern art, calling it leftist deviation, Western decadence, bourgeois, formalistic. About 1921 such painters as Chagall (page 36) and Kandinsky (page 25) left the U.S.S.R. in frustration. Even today paintings by these great expatriates are hidden away in museum storerooms (though "formalist" works by the foreigners Matisse and Picasso have gradually emerged from prison since the death of Stalin in 1953). The Soviet artists who remain are enjoined — and well paid — to paint pictures in a popular realistic style preferably with propaganda content. Other styles are forbidden and other subjects discouraged. In 1962 Khrushchev himself assaulted young artists with

* From a broadcast upon the opening of the new building of The Museum of Modern Art, May 11, 1939.

threats and scurrilous sarcasm because they deviated from Socialist Realism and dared exhibit their heresies in spite of official warning.

Why do totalitarian dictators hate modern art?

Because the artist, perhaps more than any other member of society, stands for individual freedom — freedom to think and paint without the approval of a Goebbels or a Central Committee of the Communist Party, to work in the style he wants, to tell the truth as he feels from inner necessity that he must tell it.

In this country there is little danger that the arts will suffer from the tyranny of a dictator but there are other less direct ways of crushing freedom in the arts. In a democracy the original, progressive artist often faces the indifference or intolerance of the public, the ignorance of officials, the malice of conservative artists, the laziness of the critics, the blindness or timidity of picture buyers and museums. Van Gogh was "free." He lived successively in two liberal democracies and painted as he wished. He also starved. In the end, desperate with disappointment, he shot himself, having sold only a couple of paintings in his lifetime for about $100 (they might be worth $300,000 now). Have we a van Gogh in America today? How has he been getting along? Has he found alert, courageous and generous admirers, and buyers, among private purchasers, business corporations, museums, city, state and Federal offices? Yes, more and more, but not enough.

Yet the American artist, since the war against Nazi tyranny abroad, has had to suffer occasional persecution here at home. Self-styled patriotic organizations and misguided congressmen, instigated by bitterly jealous academic artists, have accused modern artists and their supporters of communist sympathies. (It is true in the past that Communists once or twice did gain control over artists' groups, particularly during the depression and our military alliance with the U.S.S.R., but with very few exceptions, even the most gullible artists have lost their illusions about Communism — and those few exceptions have been for the most part "conservative" rather than "modern" in their art.)

At the 25th Anniversary of The Museum of Modern Art, President Eisenhower asserted "that freedom of the arts is a basic freedom, one of the pillars of liberty in our land. For our Republic to stay free, those among us with the rare gift of artistry must be able freely to use their talent. Likewise, our people

must have unimpaired opportunity to see, to understand, to profit from our artists' work. As long as artists are at liberty to feel with high personal intensity, as long as our artists are free to create with sincerity and conviction, there will be healthy controversy and progress in art."

Freedom of expression, freedom from want and censorship and fear, these are desirable for the artist. But why should the artist's freedom particularly concern the rest of us? Because the artist gives us pleasure or tells us the truth? Yes, but more than this: his freedom as we find it expressed in his work of art is a symbol, an embodiment of the freedom which we all want but which we can never really find in everyday life with its schedules, obligations and compromises. Of course we can ourselves take up painting or some other art as amateurs and so increase our sense of personal freedom; but even in a nation of amateur artists there would still be a need for the artist who makes freedom of expression his profession. For art cannot be done well with the left hand: it is the hardest kind of work, consuming all a man's strength, partly for the very reason that it is done in greater freedom than other kinds of work.

For the arts thrive, to repeat President Roosevelt's phrase, where men are free "to be in charge of the discipline of their own energies and ardors." The greater the artist's freedom the greater must be his self-discipline. Only through the most severe self-discipline can he approach that excellence for which all good artists strive. And in approaching that goal he makes of his work of art a symbol not only of truth and freedom but also of perfection.

Perfection in a work of art is of course related to the perfection of a flawlessly typed letter, or an examination mark of 100, or a well-made shoe, but it differs in several important ways: it is usually far more complicated, combining many levels and varieties of human activity and thought; it cannot be judged by practical or material results, nor can it be measured scientifically or logically; it must satisfy not a teacher, a superior officer, or an employer but first and essentially the artist's own conscience; and, lastly, artistic perfection, unlike the perfection of the craftsman, the technician or the mathematician, can be, but should not be, "too" perfect.

The possibilities open to the painter as he faces his blank canvas, or to the composer before his untouched keyboard are so complex, so nearly infinite, that perfection in art may seem almost as unattainable as it is in life. Mondrian perhaps comes in sight of perfection by limiting his problem to the subtle adjustment of rectangles (page 29). An "abstract" painter who passed beyond Mondrian into geometry would indeed find perfection, but he would leave art behind him just as, in another direction, the painters who go beyond Peto (page 12) in counterfeiting reality are expert craftsmen but scarcely artists. For complete perfection in art would probably be as boring as a perfect circle, a perfect Apollo, or the popular, harp-and-cloud idea of Heaven.

Yet the artist, free of outer compulsion and practical purposes, driven by his own inner passion for excellence and acting as his own judge, produces in his work of art a symbol of that striving for perfection which in ordinary life we cannot satisfy, just as we cannot enjoy complete freedom or tell the entire truth.

Truth, which in art we often arrive at through a "lie," freedom, which in art is a delusion unless controlled by self-discipline, and perfection, which if it were ever absolute would be the death of art — perhaps through pondering such ideas as these we can deepen our understanding of the nature and value of modern painting; but for most people the direct experience of art will always be more pleasurable and more important than trying to puzzle out its ultimate meaning. Listen to what Picasso has to say about attempting to answer such questions as "What is modern painting?" Let a painter have the last word:

"Everyone wants to understand art. Why not try to understand the song of a bird? Why does one love the night, flowers, everything around one, without trying to understand it? But in the case of a painting people have to understand. If only they would realize above all that an artist works because he must, that he himself is only a trifling bit of the world, and that no more importance should be attached to him than to plenty of other things in the world which please us, though we can't explain them. People who try to explain pictures are usually barking up the wrong tree."